CÉZANNE

CÉZANNE
Catherine Dean

Phaidon Press Limited
Regent's Wharf, All Saints Street, London N1 9PA

Phaidon Press Inc.
180 Varick Street, New York, NY 10014

www.phaidon.com

First published 1961
Reprinted 1966, 1971, 1972, 1976, 1978
Second edition, revised and enlarged, 1991
Reprinted 1993, 1994, 1998, 2000, 2001, 2002, 2003
© 1961, 1991 Phaidon Press Limited

ISBN 0 7148 2682 0

A CIP catalogue record for this book is available from the
British Library

Printed in Singapore

The publishers wish to thank all private owners, museums, galleries
and other institutions for permission to reproduce works in their
collections.

Cover illustrations:
(front) *Man with a Pipe*, c.1892–5 (Plate 35)
(back) *Landscape with a Viaduct: Mount Sainte-Victoire*, c.1885–7
(Plate 17)

Cézanne

Paul Cézanne (1839-1906) was described by Henri Matisse as 'the father of us all', by Pablo Picasso as 'the mother who protects her children', and by Paul Klee as 'the teacher par excellence'. Great praise from great artists. What makes Cézanne so special? Why do these twentieth-century artists single him out for such attention?

The very familiarity of many of Cézanne's pictures is a hindrance, making it difficult to look at them with fresh eyes. His paintings are easy on the eye: the colours are to the current taste, the subjects universal - landscapes, portraits, still lifes and figures in a landscape. The paintings from the 1870s relate closely to the work of the Impressionists, the most widely known group of painters today with a vast number of exhibitions devoted to their works every year, and whose paintings command some of the highest prices. Cézanne's work too has been the subject of several major one-man shows during the last fifteen years.

To comprehend the appeal of his work for twentieth-century artists it is necessary to look at them in some detail. This brief introduction tends to concentrate on the composition of and sources for each picture, since only through an understanding of these aspects is it possible really to appreciate the diversity of Cézanne's interests. Once the basic ideas have been identified, we have a starting point from which to approach his other paintings. Besides which, it is fun to spot his sources, to recognize the 'in-jokes' that he makes on occasion. Cézanne's reworkings of Ingres' portrait of the *Emperor Napoleon,* of Manet's *Olympia* and of Veronese's *Supper at Emmaus* all display his knowledge of the works of past masters and his ability to reinterpret them, adding something of his own beliefs and characteristics. He drew diagrams of the compositions of paintings he saw in the Louvre, made studies of individual figures, and then used these in the construction of his work. While leaving enough clues to enable us to identify the origins, Cézanne makes the paintings his own. The references to Old Masters were certainly intended to be identified; the rejection of his *Portrait of Achille Emperaire* (Plate 1) from the 1870 Salon was a surprise to him, since he felt that it conformed to the tradition of monumental portraiture.

Cézanne's best paintings are highly complex, bringing together different aspects of art and art history: knowledge of previous works, of current colour theories, of what was happening in the contemporary art and literary scenes. In a sense, his appeal to so many and various artists is precisely because of this eclectic approach; there is something here for everyone. Even during Cézanne's lifetime, fellow artists found ideas in his art that the painter himself did not intend. Gauguin, for example, admired his work enormously, writing to Pissarro: 'Has Cézanne found the exact formula for a work acceptable to everyone? If he discovers the prescription for compressing the intense expression of all his sensations into a single

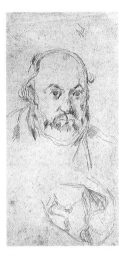

Fig. 1
Self-Portrait and
Portrait of the Artist's
Son
c.1878–82. Pencil on
paper, 21 x 12 cm. Arthur
Heun Fund, Art Institute
of Chicago

and unique procedure, try to make him talk in his sleep.' Gauguin even bought one of Cézanne's paintings and made a copy of it, but the compliment was not returned. Cézanne referred to him merely as a maker of Chinese images, despising the pattern-making qualities that Gauguin professed to find in his work.

Much of what we know about Cézanne's thoughts and ideas on the practice of painting come from his letters to friends and followers. Apart from these, there are reminiscences from about a dozen of his contemporaries. The most important for students of Cézanne's work are the account by Ambroise Vollard the influential dealer; 'Conversations with Cézanne', published by Emile Bernard in 1921, an elaboration of earlier writings; and memoirs published by Jules Borely, Leo Larguier and Joachim Gasquet, fellow Provençals. All these should be treated with caution. Emile Bernard, for example, clearly focuses on the aspects of Cézanne's oeuvre that most coincide with Symbolist theories, and the language of each account tends to be not Cézanne's but the author's.

Cézanne and the Old Masters

Throughout his painting career Cézanne referred to the work of the Old Masters. His first formal training was at the Free Municipal School of Drawing in Aix, at which he studied periodically between 1857 and 1862 under the tutelage of Joseph Gibert, who was also the curator of the museum in Aix. It was probably Gibert who introduced Cézanne to the work of the local painter, François-Marius Granet. On his death in 1849, Granet bequeathed to the museum, which was subsequently renamed in his honour, some 300 paintings and 1,500 drawings, washes and watercolours. These were scenes of Italy, of Paris, Versailles and the surrounding countryside, and of his native Provence. Although it is not known how much access Cézanne had to this collection, since it did not go on public display until the early 1860s, he undoubtedly respected Granet's oeuvre. As Ryskamp writes in his introduction to a recent exhibition of Granet's work: 'Granet's watercolours do not have a topographical exactness; they are casual, impressionistic, and meditative. They look inward, rather than to a precise description of a scene'. These qualities are to be found in many of Cézanne's paintings; perhaps especially in his views of the Mont Sainte-Victoire, a subject also painted by Granet.

Once Cézanne had begun to visit Paris, the Louvre offered many more possibilities for inspiration. Would-be students had to request

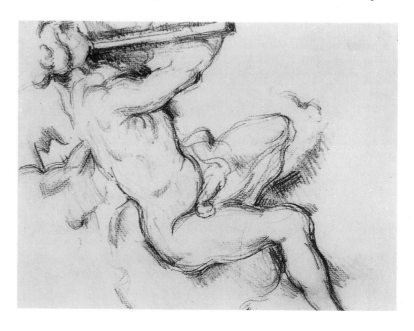

Fig. 2
Drawing after
Rubens' 'Portrait of
Marie di Medici'
Pencil on paper, 31 x 18
cm. Private Collection,
Zurich

permission to paint copies of the works, and Cézanne is first recorded applying for a permit in 1863. There are wonderful accounts by the poet Joachim Gasquet, in his book published in 1921, of afternoons spent in the Louvre with Cézanne, discussing paintings by Velazquez, Delacroix and Veronese among others. But by far the most important testimony to Cézanne's close study of earlier works are the 20 or so sketchbooks he filled with drawings of paintings and sculptures. There are over 30 copies of works by Rubens alone (whom he described in a questionnaire filled in during the late 1860s as his favourite painter), such as his *Drawing after Rubens' Marie di Medici* (Fig. 2), a few after Poussin, diagrams of the compositions of Veronese's *Supper at Emmaus*, (Fig. 33) and *Marriage at Cana*, drawings of Michelangelo's *Dying Slave* and *Rebel Slave* (Fig. 3), sculptures by Pigalle, and many more.

From these, Cézanne learned much about composition and colour. Ambroise Vollard wrote about his experience of posing for a portrait by Cézanne in 1899 (see Plate 41). These sessions would last from eight till 11 in the morning. In the afternoons Cézanne would go to the Louvre to study. One day, Vollard drew the artist's attention to some spots of canvas left unpainted. Cézanne replied: 'If the copy I'm making at the Louvre turns out well, perhaps I will be able tomorrow to find the exact tone to cover up those spots'.

In 1869 another bequest, this time to the Louvre, formed an early influence on Cézanne's choice of subject matter. The La Caze collection of still lifes by Jean Baptiste Chardin, the eighteenth-century French painter, was largely responsible for changing the attitude of the French art establishment to this previously lowly-regarded genre. The annual Salon exhibitions were filled with historical, biblical and mythological works, felt to be more worthy subject matter. The quality of Chardin's work was quite unlike anything else in the Louvre collection, and the subsequent rise in status of the still life may well have been the impetus for works such as *The Black Marble Clock* (Plate 6). Indeed, in 1862 Manet's attention was first drawn to Cézanne by work in this area.

Several of Cézanne's statements bear out the importance he placed on study of the Louvre's masterpieces. 'Couture used to say to his pupils: keep good company, that is: go to the Louvre. But after having seen the great masters who repose there, we must hasten out and by contact with nature revive within ourselves the instincts, the artistic sensations which live within us.' Again, as late as 1905 in the last year of his life, he wrote to Emile Bernard: 'The Louvre is the book in which we learn to read. We must not, however, be satisfied with retaining the beautiful formulas of our illustrious predecessors. Let us go forth to study beautiful nature, let us try to free our minds from them, let us strive to express ourselves according to our beautiful temperament. Time and reflection, moreover, modify our vision little by little, and at last comprehension comes to us.'

An illustration of this thinking put into practice can be seen in Cézanne's use of the studies he made of Michelangelo's unfinished statue of the *Dying Slave*, made for the tomb of Pope Julius II in 1513-15. This, together with the *Rebel Slave* (Fig. 3), was eventually withdrawn from the monument in its final form and presented by Michelangelo to his friend Roberto Strozzi, who in turn gave them to King Henri II of France as an act of homage. The two sculptures passed through the royal family and finally entered the Louvre collection in 1794. They were originally interpreted as allegories of the liberal arts reduced to powerlessness by the death of the Pope, their patron and protector. Cézanne has drawn the statue and then,

to paraphrase, freed his mind from it and striven to express himself according to his temperament. He does not reuse the image in its original context; he simply takes the pose and places it in another picture. The figure on the upper left of *The Temptation of St. Anthony* (Plate 5), is the *Dying Slave* transformed into a voluptuous temptress of the saint. Over 30 years later the same pose reappears in *The Large Bathers* (Fig. 15), given back to a male figure again. This disregard for context and even for gender is found in many of Cézanne's borrowings from the Old Masters.

Cézanne was also attracted to images which readily lent themselves to his subjects. *Woman in a Fur Coat* (Fig. 4) is based on El Greco's *Lady in an Ermine Coat*. An engraving of this had been reproduced in the 'Magasin Pittoresque' in 1860. Her features are remarkably like those of Madame Cézanne, as Venturi has observed.

Fig. 3
Drawing after
Michelangelo's
Rebel Slave
(1513–15)
c.1884–7. Graphite pencil
on paper, 27.3 x 21 cm.

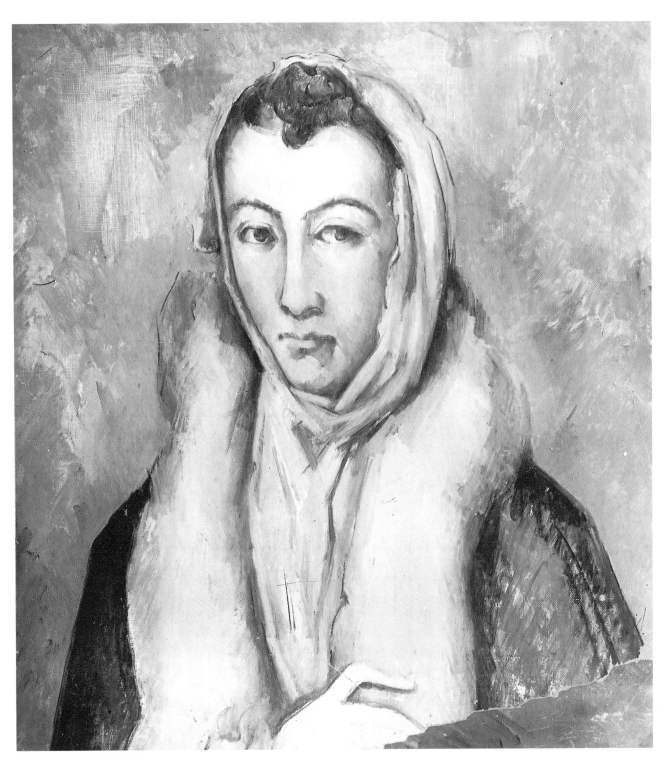

Fig. 4
La Dame à la
Fourrane, after El
Greco's 'Dame à
l'Hermine'
c. 1879–82. Oil on canvas,
53 x 49 cm. Private
Collection, Paris

Fig. 5
Portrait of the Artist's
Father
1866. Oil on canvas,
198.5 x 119.3 cm.
National Gallery of
Art, Washington

Cézanne and the Impressionists

Cézanne's move to Paris was not easily achieved. His father, Louis-Auguste (Fig. 5), had been a dealer and importer of felt hats before establishing himself in Aix in 1839. In 1848 he changed his profession to banker, thus becoming an increasingly important figure in provincial society. Despite indulging his son's early artistic inclination, allowing him to decorate the rooms of the Jas de Bouffan (the family home purchased in 1859) with murals and screens, the bourgeois Louis-Auguste clearly wished his son to enter a respectable profession. He even bought Cézanne a substitute so that he could avoid military service and continue his studies in law at the University of Aix. Cézanne, however, had other ideas, prompted no doubt by reports of Parisian life from his childhood friend Emile Zola; and after some considerable disagreement with his father he departed for the capital in 1861.

Apart from Zola's circle of acquaintances, such as Paul Alexis, whom he painted in Zola's garden in Paris (Fig. 6), Cézanne also met people through his study at the Académie Suisse, including François Oller, a painter with whom he shared an apartment for a time, and Antoine Guillemet. Guillemet was an important contact, persuading Cézanne's father to increase his son's allowance in 1866, thus allowing him to continue to paint, and in 1882 using his influence as a member of the jury at the Salon to accept one of Cézanne's paintings, a portrait of a man, for exhibition as a 'pupil' of Guillemet. Also at the Académie were Jean-Baptiste Armand Guillaumin and Camille Pissarro, who introduced Cézanne to other artists in what was to become the Impressionist 'group': Frédéric Bazille, Claude Monet, Pierre-Auguste Renoir and Alfred Sisley. These painters, together with writers and journalists such as Astruc, Zola, Silvestre and Duret, frequented the Café Guerbois on the rue des Batignolles (now the Avenue de Clichy), where every Friday evening the Realist critic Edmond Duranty would host a friendly debate about the art and literature of the period. Less regular visitors were Degas and Manet. Monet later recalled: 'Nothing could be more interesting than these causeries with their perpetual clash of opinions. They kept our wits sharpened, they encouraged us with stores of enthusiasm that kept us up for weeks and weeks until the final shaping of ideas was accomplished. From them we emerged with a firmer will, with our thoughts clearer and more distinct'. Two other visitors to the café were fellow Provençals, Adolphe Monticelli and Paul Guigou, with whom Cézanne felt a patriotic rapport.

The advent of the Franco-Prussian war in 1870 broke up the group; but even when it reconvened at the Café La Nouvelle-Athènes afterward, Cézanne was never a frequent participant of these weekly occasions. He was solitary by nature, rather shy, and also he appears deliberately to have cultivated an air of provincial uncouthness. He apparently once refused to shake Manet's hand, explaining that he had not washed or changed his clothes for some days. One senses that Zola's gradual withdrawal, culminating in the complete break of 1886 with the publication of his novel 'L'Oeuvre' - in which a struggling and unsuccessful artist is patently based on Cézanne - was at least partly because he had become exasperated with Cézanne's uncivilized behaviour.

Cézanne's ally during the 1870s was Camille Pissarro, eight years his senior. In 1872 Cézanne, together with his mistress Hortense Fiquet and their young son Paul, left Paris to live in Auvers-sur-Oise, a small village near Pontoise, Pissarro's home. The two artists often painted the villages and surrounding countryside together and even

11

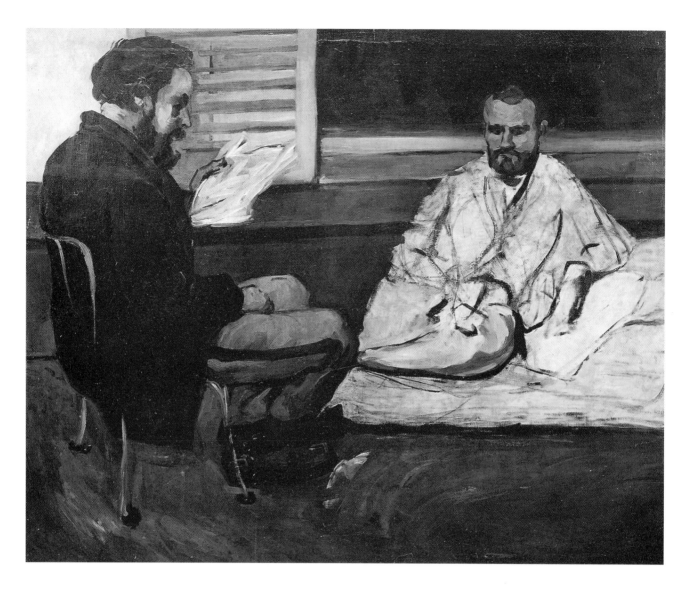

drew each other (Fig. 7). Cézanne admired and respected the older master enormously, and from Pissarro he learned about painting outdoors – *en plein air* – and also to lighten his palette. The work he produced during the mid-1870s is his most Impressionist, such as *The House of the Hanged Man* (Fig. 8). Furthermore, it was Pissarro who persuaded him to exhibit with the group in the first Impressionist exhibition in 1874, the Société anonyme des artistes, peintres, sculpteurs et graveurs, showing *The House of the Hanged Man*, *A Modern Olympia* (Plate 7), and a *Landscape at Auvers*. Again, it was Pissarro who introduced Cézanne to Dr. Gachet and Julien 'Père' Tanguy, who became friends and patrons; Renoir took him to meet Victor Chocquet, whom he painted in c.1879-82, (Fig. 9).

Although Cézanne exhibited again at the third Impressionist exhibition in 1877, at the prompting of Pissarro and Gustave Caillebotte, another supporter, the criticism that his paintings received at the exhibition was so unfavourable that he withdrew from the circle.

Despite the many similarities between some of Cézanne's paintings and those of Pissarro made at the same time, there remain important differences. Cézanne's scenes of country villages are not populated like Pissarro's with peasant figures working productively and harmoniously in the countryside. The one exception is an extraordinary caprice dating from c.1875-7 called *The Harvest*, which

appears to be a reworking of Poussin's painting from 1660-4, *Summer, or Landscape with Ruth and Boaz*. It was almost certainly the example of the Old Master, rather than of Pissarro, that inspired him to paint such a scene of rural labour. Neither did Cézanne ever fully adopt the Impressionist palette, continuing to use black; or the Impressionist brushstroke, developing his own 'constructive' stroke; or typical Impressionist subjects, such as the café-concerts, boating parties or man-about-town, the *flâneur*. Nor was Cézanne impressed by the Japanese prints which so impressed Degas and Van Gogh, and later the Symbolists, with their innovatory compositions, cut-offs and pattern-making effects.

In later years Cézanne strengthened contacts with Monet and Renoir, inviting the latter to stay with him in Aix in 1888, where they worked together and painted the same scenes. In 1894 Cézanne visited Monet in Giverny, where he met Auguste Rodin, who shook his hand. Cézanne was so deeply moved by this experience that he burst into tears. Both Monet and Renoir were attracted by the warm Mediterranean light of the south, and spent some time painting along the coastline near L'Estaque and Marseilles.

Cézanne's Technique

Cézanne's painting technique changed considerably during the 45 years or so that he was active as a painter. The early, pre-Impressionist works are done in thick, juicy strokes of paint, dominated by black and warm earth tones, as in the *Portrait of Achille Emperaire* (Plate 1), *The Rape* (Fig. 13) and *The Black Marble Clock* (Plate 6). He also experimented freely with the palette knife as a means of laying on the paint, which gave a rather slab-like surface to the canvas.

His training at the Académie Suisse between 1861 and c.1863 followed the usual pattern for young artists. The school was one of several independent alternatives to the Royal Academy, founded in the 1640s, which concentrated its efforts on teaching students to draw and paint historical landscapes. 'Père' Suisse, an ex-model from David's studio, established his own atelier on the corner of the quai des Orfèvres in Paris. He based his instruction on drawing from the live model, for the first three weeks of each month from a male nude, for the last one from a female.

Ingres, Courbet and Manet had also studied at the Académie Suisse. Zola had heard of it before Cézanne enrolled, writing to their mutual friend Baptistin Baille: 'Chaillan claims that the models are tolerable there, although without being prime material. They draw them during the day, and caress them at night (the word caress is a bit weak). So much for the day sitting, so much for the night sitting; it is said that they are quite accommodating, especially for the nightime hours. As for the fig leaf, it is unknown in the studios; they undress with great familiarity, and the love of art hides all that might be exciting in this nudity'. Despite this daily contact with nude models Cézanne remained ill at ease with live sitters; but the exercise did mean that he was able to draw accurately and with confidence, simply through repetition and enforced familiarity with the human body. It must be remembered, when looking at all the later works in which the limbs of his figures are overlong, or distorted, such as *The Boy in the Red Waistcoat* (Plate 26), or *The Card Players* (Plate 34), that Cézanne could, when he wished, draw figures with the correct proportions.

Fig. 7
Pissarro going off to Paint
c.1874–7. Pencil on paper, 20 x 11 cm. Cabinet des Dessins, Musée du Louvre, Paris

Fig. 8
The House of the
Hanged Man
1873–4. Oil on canvas,
55 x 66 cm. Musée
d'Orsay, Paris

The most significant factor in the evolution of Cézanne's style during the 1870s was the influence of Pissarro. As mentioned earlier, Cézanne moved to Auvers-sur-Oise in 1872, where he and Pissarro painted the village and surrounding countryside, sometimes side by side. The change in his technique is considerable. In works such as *The House of the Hanged Man* (Fig. 8) we can see the build-up of layers of paint applied with a practically dry brush, so that each new colour is encrusted on top of a dried one. This layering of thick, opaque paint gives a rough texture to the surface, which breaks up and refracts light, so that the picture gains a luminosity and brightness by virtue of the paint surface as well as through the use of colour.

By the end of the 1870s Cézanne had evolved a diagonal hatching stroke that – evenly applied throughout the picture, regardless of the texture or nature of the object – unified the various pictorial elements in a tightly interlocking structure. *The Bridge at Maincy, near Melun* (Plate 11) is one of the best examples of this knitting of brushstrokes. Leaves, wood, stone and water are all constructed from individual directional marks of colour. This same directional brushstroke is used again in *Mountains seen from l'Estaque* (Plate 22), painted some ten years later, following the curves of the skyline and the planes of the interlocking spurs in the fore-and middle-ground. In places he allows the cream ground of the prepared paper to show through, so that it becomes a colour in its own right. In many of his later works he experiments with exactly the same effect, as in, for example, the late painting of Mont Sainte-Victoire (Plate 47).

Cézanne's use of this technique was deliberate, and reflected his interest in the relationship of the painting as a representation of the scene before him to the reality of the two-dimensional canvas covered with paint. He realized, for instance, that as he could not reproduce sunlight, he would have to represent the effect of light by means of colour. Allowing the canvas or paper surface to show through the paint layers was another way of asserting the artificiality of the painted landscape. The same point was made by his flattening of the picture space, achieved through the composition and by tilting up towards the viewer the objects before him.

Two later paintings reproduced here are good examples of his handling of light and shadow: *The Village of Gardanne* (Plate 18) and *Bathing Women* (Plate 43). In both, Cézanne makes use of the fact that warm colours advance and cool ones recede. The block-like houses of Gardanne are fashioned in warm colours, interspersed with cool greenish blue masses of foliage, so that a continual overlapping of planes and shifting surface effect is achieved. The bathers are modelled in the same way. Their bodies and limbs are painted in warm pinks, oranges and yellows, giving them roundness and volume, while the outlines are painted in deep blue colours, the darker colours receding and making the forms curve away from us.

Cézanne did not paint only in oils. As already observed, he drew from paintings in the Louvre whenever he was in Paris. These were often, although not invariably, used as studies for part of a larger, more complex composition. In contrast, his many watercolours were only rarely used as preliminary studies for oil paintings, even though the subjects he treated - figure studies, landscapes, still lifes and bathers - were the same as those he painted in oil.

Cézanne's first interest in watercolour is recorded in a letter to Zola of 1866: 'The picture is not going too badly, but a whole day passes very slowly; I ought to buy a box of watercolours to work during the time I do nothing to my picture'. The advantages of

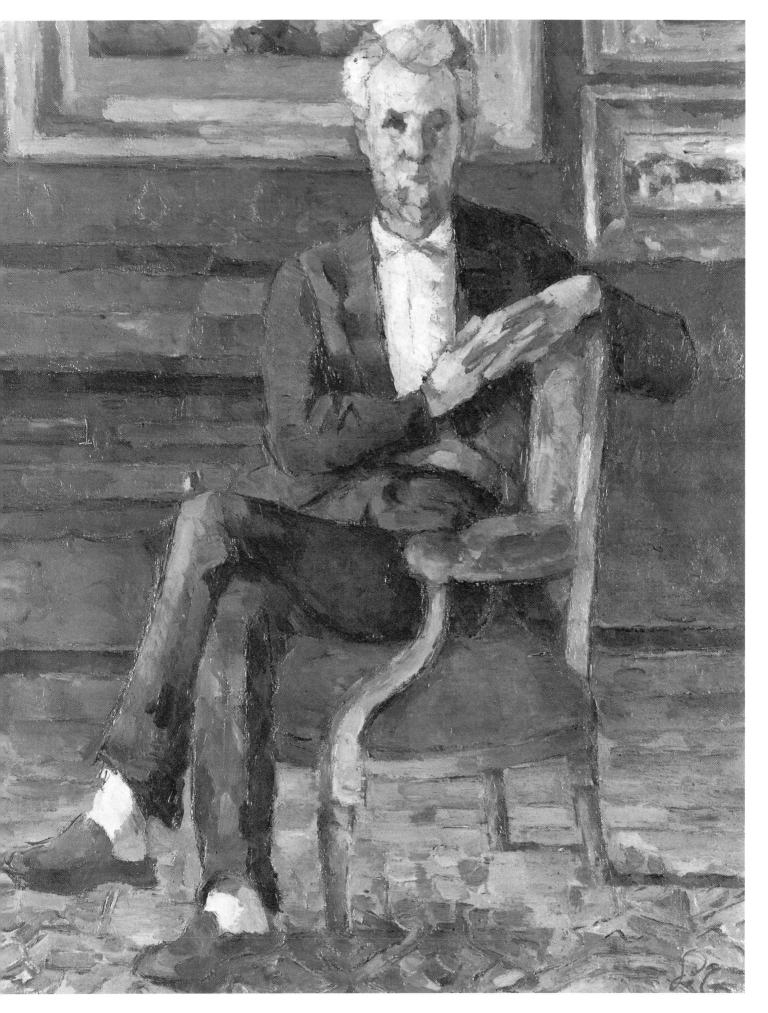

watercolour for Cézanne are obvious. They were comparatively cheap, they were quick to use, and they were portable. As with his painting in oil, his style and technique altered over the years. Initially he painted with gouache, that is, opaque colours mixed with water. This produces an effect not dissimilar to that of oil.

After only a year of experimentation with this new medium, one of Cézanne's friends wrote: '[Cézanne's] watercolours are particularly remarkable, their colouration is amazing, and they produce a strange effect of which I did not think watercolours were capable'. During the 1870s, when his contact with Camille Pissarro was revolutionizing his approach to painting in oil, Cézanne used watercolour largely to heighten his pencil sketches with colour. It was not until he evolved the constructive brushstroke at the end of the decade, which destroyed the local texture of objects, that he realized the potential of watercolour: it allowed him to produce a very sketchy, loosely painted image. There could be no criticism that the work was a sketch or unfinished, an accusation frequently hurled at the Impressionists.

The very characteristics of watercolour painting were instructive. Cézanne had to paint lightly; in oils he had a tendency to overpaint. There is a story that the first owner of *A Modern Olympia* (Plate 7), took the painting away from Cézanne, fearing that the artist would otherwise overwork it. Furthermore, he could experiment with leaving areas of the paper unpainted, which he later tried out in his oils, as in the *Still Life* (Plate 32) and the *Mont Sainte-Victoire* (Plate 47). The cheapness of paper and watercolour compared to canvas and oil made it the obvious medium for trying out new ideas.

Cézanne gradually developed an idiosyncratic watercolour style. Emile Bernard, who visited him in 1902, later described his method of overlapping patches of colour, which had been allowed to dry, with more coloured patches. The technique was extremely laborious – not at all the usual practice of laying in quick washes of colour which blend into each other. In some of his late watercolours there are almost no traces of pencil outline (see Plate 45). This may have been due to his familiarity with the subject; knowing the forms so well he did not need to concentrate on getting the shapes accurate, and was free to play with colour. The study for the Chicago *Bathers* (Fig. 31), is a mass of curling brushstrokes describing the figures and foliage. In contrast, the *Still Life* of c.1906 (Fig. 28), displays his attention to drawing, with repeated outlines of the curved flask and fruit. In 1902 Vollard visited Cézanne in Aix to discuss a possible one-man exhibition devoted to watercolours. Cézanne's son, who acted as his father's agent, wrote to Vollard shortly afterwards: 'At the moment I am digging and searching through my father's portfolios. I hope to garner from them some watercolours sufficiently finished to increase the number of those you plan to exhibit upon my return to Paris'. The show eventually took place in 1905. No catalogue appears to have been published but, from a review by Charles Morice, we can tell that a wide range of dates and subject matter was represented.

Unlike the other Impressionists, Cézanne never tried working in pastel or sculpture. However he did experiment a little with prints and lithographs, first in 1873, when his contact with Pissarro, Dr. Gachet and Armand Guillaumin, all print enthusiasts, encouraged him to try. His efforts at producing lithographs were similarly prompted by someone else, in this case Vollard, who wanted to commission contemporary artists to produce graphic work which he could sell in deluxe albums. Cézanne worked on three images, based on a self-portrait, a *Small Bathers*, and a *Large Bathers*. Fig. 15

reproduces one of the versions he made of the latter. The composition of the *Large Bathers* was developed from numerous preliminary sketches; the poses are ones used again and again. He made prints in black and white, some of which he heightened with watercolour to serve as models for the eventual colour printings.

Cézanne's Subject Matter

Cézanne never spent very long in Paris without feeling the need to escape to the countryside; whether to Pontoise and Auvers with Pissarro, or back to his native Aix. These periods of retreat were in part due to his insecurity with his peers at the Café Guerbois and Café la Nouvelles-Athènes. The somewhat nomadic nature of Cézanne's life can also be attributed to the development of the French rail network in these decades. The Aix to Paris link had opened in 1856, which naturally assisted his movement between the two, and the extension of the line to Marseilles in 1876 meant that he could visit l'Estaque more easily. This expansion of the rail network was even more significant in allowing people to travel, in creating tourism. Parisians flocked to the countryside and the coast in ever increasing numbers. So while Cézanne could travel to the Bay of Marseilles to paint works such as *The Bay of Marseilles, seen from l'Estaque* (Plate 21), numerous other people could visit the area too. Cézanne complained bitterly about the spoiling of the village of l'Estaque in a letter of 1902, explaining that this was why he had not returned to the coast after the 1880s.

Cézanne returned to Aix not merely because Paris occasionally became too overwhelming. It must be remembered that the town held many associations for him. He had spent happy days there with Zola and Baille, hunting, exploring and swimming in the dam that Zola's father had designed. Furthermore, Aix was a flourishing town in its own right. Established by the Romans at the end of the second century B.C., it became the capital of Provence until its annexation by the French monarchy in 1481. By the end of the 1880s, with a population of around 29,000, Aix was the centre of a revival of interest in all things Provençal. André Gouirand, for example, published a history of the region's modern painters that traced its roots back to the mid-eighteenth century and François Duparc, a local painter represented in the museum in Aix. Cézanne's *Old Woman with a Rosary* (Plate 39) was painted in homage to Duparc's *Woman Knitting,* in the Musée des Beaux-Arts, Marseilles. Cézanne wrote to Henri Gasquet in 1899: 'Last month I received a number of the Memorial d'Aix, which published at the head of its column a splendid article of Joachim's [Gasquet] about the age-old titles to fame of our country. I was touched by his thoughtfulness and I ask you to interpret to him the sentiments which he has reawakened in me, your old schoolfellow at the Pensionat St. Joseph; for within us they have not gone to sleep for ever, the vibrating sensations reflected by this good soil of Provence, the old memories of our youth, of these horizons, of these landscapes, of these unbelievable lines which leave in us so many deep impressions.'

Lastly, the light in Provence and on the Mediterranean coast was altogether different from that in Paris and northern France; it was lighter, brighter and made the colours more vibrant. Cézanne wrote to Pissarro from l'Estaque in 1876: 'I have started two little motifs with the sea, for Monsieur Chocquet, who had spoken to me about them. It's like a playing card. Red roofs over the blue sea... The sun here is so tremendous that it seems to me as if the objects were silhouetted not only in black and white, but in blue, red, brown and

violet. I may be mistaken, but this seems to me to be the opposite of modelling...' Monet's and Renoir's visits to the south in the 1880s and 1890s were for exactly this reason.

From about 1870 until his death in 1906, it is possible to see how the countryside, especially that of his native Aix, increasingly became for Cézanne an escape from the realities of modernization, urbanization and industrialization. Both in his choice of subject matter and in the way in which he depicts it we see a continual avoidance of modernity. The still lifes, which are by their very nature timeless, refer back to works by earlier masters such as Chardin. Cézanne's comments to Vollard while painting the latter's portrait (see Plate 41), clearly illuminate his liking for painting objects such as apples, which were immobile and unchanging - he did, on occasion, paint from artificial fruit to combat the effects of decay. The absence of hands in *The Black Marble Clock* (Plate 6) has been interpreted as indicating a lack of specific time. Throughout his career, Cézanne painted still lifes including skulls, an obvious symbol of mortality. In one of them a young boy contemplates a skull, in much the same way that the seventeenth-century Dutch painters portrayed children blowing bubbles, a standard metaphor for the brevity of life. This concern with the cyclical pattern of life and death is far removed from the Impressionists' attempts to catch the fleeting effects of the weather.

Cézanne's portraits are equally unconcerned with topicality. The lack of expression in their faces and the borrowing of poses from the Old Masters similarly create a timeless aura. The paintings of the inhabitants of Aix and of the Jas de Bouffan are even more solid and monumental, both in scale and in the quality of repose. Cézanne was not interested in painting society portraits of people in the latest fashions; instead the peasants are dressed in their everyday working clothes. The bathers, too, belong to a long tradition of pastoral landscapes, with precedents ranging from Giorgione to Watteau to Manet.

It is in the landscapes, however, that the clearest proof of Cézanne's avoidance of the modern is to be found. His study of Poussin and other masters in the Louvre account for the classicism of his landscapes, for example the framing trees in *The Sea at l'Estaque* (Fig. 26); the branches of the tree following the curve of the mountain in the *Montagne Sainte-Victoire* (Plate 16 and Fig. 23); the use of the repoussoir in *The Lac d'Annecy* (Plate 40); the forming of clouds into shapes mirroring elements in the landscape, as in *Dr. Gachet's House at Auvers* (Plate 8). This adaptation of nature, making it conform to classical ideals, results in an ordered, balanced, harmonious composition in which everything is in its place. Even where modern elements are allowed to intrude, they are appropriated for compositional and naturalizing purposes. The viaduct in the *Landscape with a Viaduct* (Plate 17), for example, 'becomes' a branch so that it can support the unattached clump of foliage to the left of the central tree. The inclusion of a viaduct in the landscape had already been sanctioned by Poussin in his *Moïse sauvé des Eaux*, 1638, on display in the Louvre. The tall chimney in *The Bay of Marseilles, seen from l'Estaque* (Plate 21) changes from light warm hues at the base to dark cool ones at the top, imitating the passage from land to sea up the canvas surface.

There are even clearer instances of Cézanne's deliberate hiding of modern developments in the countryside. The choice of viewpoint and central motif in *The Bridge at Maincy, near Melun* (Plate 11) is an unusual one, since Maincy is a small village lying next to the

impressive gardens of Vaux-le-Vicomte, laid out by Le Nôtre in the seventeenth century. This would have been a much more obvious scene to depict, with its grand vistas and regal associations. Cézanne, however, chooses to focus on the bridge connecting Maincy with the mills in the neighbouring hamlet of Trois-Moulins. He has nearly screened off the mills on the left with a mass of trees and foliage. The bridge itself is not a miracle of modern engineering, like the railway bridge over the river at Argenteuil, painted by Monet and Sisley, but a simple construction of wood and stone. Furthermore, a comparison with photographs of the river Almont at this spot show that it flowed rapidly here. Cézanne, however, makes it seem calm and slow moving, partly so that he can fully utilize the reflections as compositional devices, but also surely to create an image of tranquility and of unblemished nature.

Something of the conflict that Cézanne found between the ideal of unspoiled nature and the reality of modern encroachment is evident in his paintings. In a significant number of works there is a certain difficulty or tension in the composition. This can be interpreted as an indication of Cézanne's unease with urban life and also as a means of exploring the dialogue between the picture as a portrayal of the scene before him and the canvas as a surface covered with paint.

For example, one of the most common devices used to create a feeling of depth in a painting is the placing of an object diagonal to the picture plane. In *Still Life with Glass, Fruit and Knife* (Plate 9), the angle of the knife leads us into the painting; the inward pointing line of the sofa in *A Modern Olympia* (Plate 7) provides a means of entry, as it were, into the room; the road in *La Montagne Sainte-Victoire* (Plate 16), serves the same purpose, creating a sense of spatial recession.

In many more of his works, however, Cézanne seems to experiment with providing a way into the picture and then abruptly breaking it off. In *The House of Dr. Gachet at Auvers* (Plate 8), and in *Turn in the Road* (Fig. 10), he employs the traditional device of a winding road to lead the eye into the landscape. Rather than meandering gently to the distant horizon, however, these roads suddenly disappear out of sight, behind a house or a wall, preventing any further penetration of the scene. This denial of access is found again and again. In *The Railway Cutting* (Plate 2), the garden wall of the Jas de Bouffan divides us from the subject of the title. Cézanne cannot have been against the introduction of the railway to Aix, since it allowed him to travel to Paris and to escape from his father's attitude to his painting; yet he has chosen the safety of the grounds of his home from which to view the cutting excavated for the railway. Neither has he painted the actual train, the means of his visits to the much-loved Louvre; instead, at the centre of the picture is a void, the empty space created for the railway.

In other paintings there is no immediate foreground, so that the viewer is not given a position from which to survey the landscape. In *The Bridge at Maincy, near Melun* (Plate 11) we apparently stand in the middle of the river. In *The Bay of Marseilles, seen from l'Estaque* (Plate 21), and *La Montagne Sainte-Victoire* (Plate 16), it is as if we are suspended in mid air above the scene, unrelated to and indeed alienated from the landscape before us. In a sense, Cézanne is interested in the idea of the 'prospect' as in eighteenth-century English painting. Whereas those pictures were intended to allow the owner of an estate to survey his domain and to remind him of his sovereignty in that region, Cézanne seems to deny any such total

Fig. 10
Turn in the Road
c.1879–82. Oil on canvas,
60.5 x 73.5 cm. Museum
of Fine Arts, Boston

Fig. 11
Portrait of Gustave
Geffroy
1895. Oil on canvas,
116.2 x 88.9 cm.
Musée d'Orsay, Paris

view of and therefore command over nature. He places a solitary tree in the centre of *Landscape with a Viaduct* (Plate 17), partially obscuring the Arc valley.

Even where Cézanne does provide a 'platform' from which to survey the countryside, as from the *repoussoir* bank in *The Lac d'Annecy* (Plate 40), he tends to tilt up the landscape by means of composition and by using a uniform brushstroke for near and distant features, regardless of texture, so that we are not immersed in the landscape but made conscious of the two-dimensionality of the canvas surface. The linking of fore- to background by the trees in *The Lac d'Annecy* and in the *Landscape with a Viaduct*, discussed in the captions to each plate, serve to 'telescope' the pictorial depth.

Only in his later work does Cézanne immerse himself fully in the landscape. The wooded scenes painted in the Forest of Fontainebleau, such as *Sous-Bois* (Plate 33), or in the estate of the Château Noir (Plate 46 and Fig. 34), are truly nature in its purest state. Cézanne was attracted to the Château not because of local legends or by its scale, but by its delapidation. The subject of nature taking back the ruined building was what interested him, indeed he only glimpses the Château Noir through the trees, so dense are they.

Criticism and Acclaim

In general, Cézanne's work was not well-received until the turn of the century. He submitted paintings for the Salon every year until 1885, when he gave up, but on nearly every occasion he was rejected. In 1866, despite the intervention of Daubigny, an established landscape painter, his works were refused, and in retaliation Cézanne wrote a polite but firm letter to the Superintendent of the Beaux-Arts, Monsieur de Nieuwerkerke, saying: 'I cannot accept the unauthorized judgments of colleagues to whom I myself have not given the task of appraising me', and demanding, 'let the Salon des Refusés be re-established'. The early *Portrait of Achille Emperaire* (Plate 1) was one of the few paintings that Cézanne signed, presumably because he intended to enter it for the Salon together with a nude, now lost. He was interviewed by a correspondent of the 'Album Stock', which published mocking extracts from their conversation together with a caricature of Cézanne and of the two rejected works.

To get his work seen by the public Cézanne, at Pissarro's encouragement, entered several paintings to the first and third Impressionist exhibitions in 1874 and 1877. Differences with his peers however, led him to write to Pissarro on the occasion of the fourth show in 1879: 'I think that, in the middle of the difficulties caused by my sending in to the Salon, it would be more appropriate for me not to take part in the Exhibition of the Impressionists'.

Cézanne suffered financial hardship for many years, until the death of his father in 1886, upon which he inherited part of the estate of the Jas de Bouffan. His father, although considerably wealthy, gave Cézanne only a very meagre allowance because he disapproved of his informal relationship with Hortense Fiquet, his mistress and the mother of his son. The couple eventually married in April 1886, giving them only six months of reconciliation with the artist's parents before his father's death. Cézanne had tried to keep knowledge of the existence of Hortense and the young Paul from his parents, but his father found out accidentally in March 1878 and halved Cézanne's allowance of 200 francs a month. There are several letters from Cézanne to Emile Zola, who by now was fairly well established, asking for loans on his own behalf and for other im-

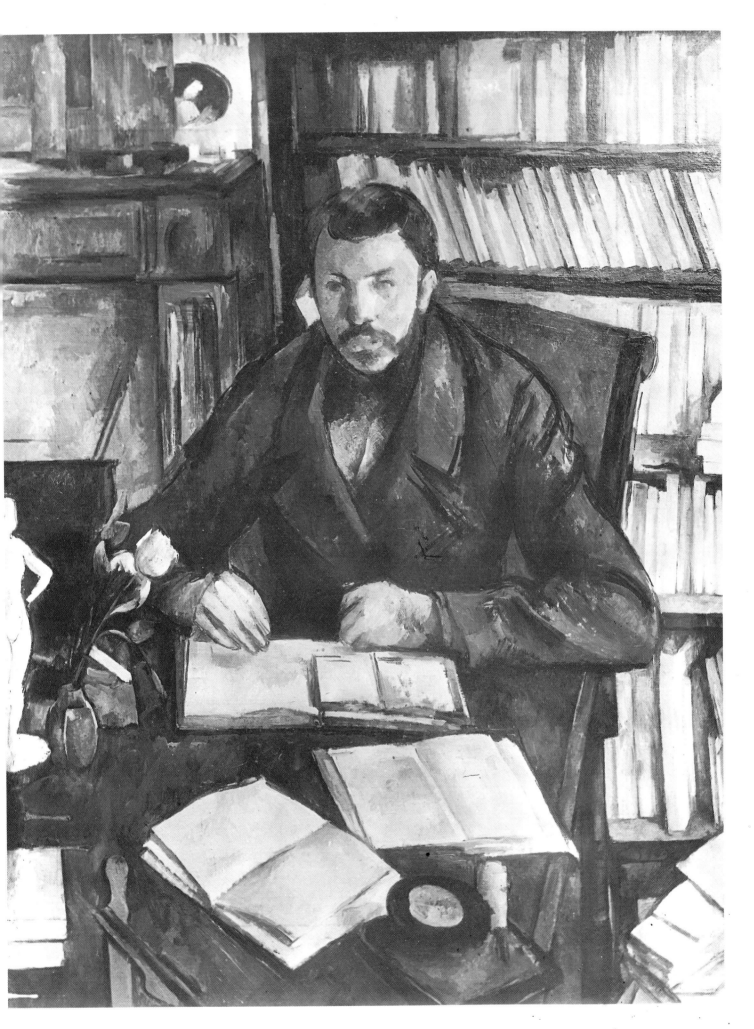

poverished artists such as Achille Emperaire. There is an amusing postscript; a letter dated September 1878 says: 'Father gave me 300 francs this month. Incredible. I think he is making eyes at a charming little maid we have at Aix...'

Cézanne's main encouragement, and some income, came from friends and patrons. Victor Chocquet, a customs official who spent most of his income on art, formed the largest early collection of Cézanne's paintings. Gustave Geffroy, whose portrait Cézanne began to paint but left unfinished, (Fig. 11), supported the Impressionist group in his articles and criticism from the 1880s onwards. He met Cézanne at Monet's house in 1894, on the same occasion (Monet's 54th birthday party) as the introduction to Rodin mentioned earlier, and offered the artist his support. However, the relationship between the two men was never a close one, and Cézanne blamed Geffroy in part for his loss of privacy in the late 1890s and early 1900s, when numerous disciples came to visit him in Aix.

The most important figure for Cézanne in the Paris art scene was Ambroise Vollard who, at Pissarro's persuasion, held the one-man exhibition of Cézanne's work in 1895. This was a retrospective sampling of about 150 works, resulting in increased sales and public discussion. Furthermore, the deaths of Duret in 1894 and Chocquet and Doria in 1899 resulted in auctions of their possessions. The dealer Durand-Ruel bought many Cézannes from the Chocquet sale, and in 1900 was able to send twelve paintings to Paul Cassirer in Berlin for an exhibition, the first on Cézanne to be held in Germany. Unfortunately, none of them sold and all were returned to Paris in the following year. It seems that Germany was not ready for such paintings; in 1897 two of Cézanne's pictures were hung in the Berlin National Gallery, but they were banned by the Kaiser.

Cézanne fared better elsewhere, exhibiting with a group called Les XX in Brussels in 1890, at Les Indépendants and La Libre Esthétique in Brussels in 1901 and the two following years. Even as late as 1903 however, when Zola's collection was auctioned after the author's death, Cézanne's paintings were attacked and ridiculed in the press. By now though, the number of exhibitions and reviews had snowballed.

In 1910, four years after Cézanne's demise, Roger Fry held the seminal exhibition of Post-Impressionist work at the Grafton Galleries in London. This included work by Manet, Cézanne, Van Gogh, Gauguin and the French Symbolists. The term 'Post-Impressionism' was coined by Fry to distinguish the paintings of Cézanne and his contemporaries from those of the 1870s Impressionists. His writings and the commercial success of the exhibition meant that Cézanne's subsequent fame was assured.

Outline Biography

1839 Paul Cézanne born in Aix-en-Provence.

1852 Attends local school, the College Bourbon, where he befriends Emile Zola.

1857 Begins at the Free Municipal School for Drawing in Aix.

1861 After disagreement with his father, he makes the first of many visits to Paris.

1861-1863 Studies at the Académie Suisse and meets the Impressionists.

1869 Lives together with Hortense Fiquet, his mistress.

1870 Escapes military service in the Franco-Prussian War by retreating to l'Estaque.

1872 Birth of his son, Paul. With his small family he moves to Auvers-sur-Oise with Pissarro.

1874 Exhibits at the first Impressionist exhibition.

1877 Exhibits at the third Impressionist exhibition.

1882 Successfully enters a picture for the Salon.

1886 Deeply hurt by the publication of Zola's novel 'L'Oeuvre'. Marries Hortense and settles more permanently in the Aix region, disillusioned with further rejections from the Salon. Death of his father; inherits the Jas de Bouffan.

1890 Visits Switzerland, his only journey outside France. Exhibits with Les XX in Brussels for the first time.

1895 First one-man exhibition in Vollard's gallery. Two of his paintings enter the Musée du Luxembourg via the Caillebotte bequest.

1897 Death of his mother, forced to sell the Jas de Bouffan to divide the inheritance with his sisters.

1900 Works shown in exhibitions in Paris, Berlin and elsewhere, his reputation begins to spread. Spends most of the rest of his life in Aix, where disciples visit him.

1906 Dies 23 October.

Select Bibliography

Monographs

Adrien Chappuis: *The Drawings of Paul Cézanne. A Catalogue Raisonné*. London, 1973.

Richard Kendall (ed): *Cézanne by Himself*. London, 1988.

Erle Loran: *Cézanne's Composition*. Berkeley, 1943.

John Rewald: *Paul Cézanne: The Watercolours. A Catalogue Raisonné*. London and New York, 1983.

John Rewald: *Cézanne and America, Dealers, Collectors, Artists and Critics, 1891-1921*. London, 1989.

Richard Shiff: *Cézanne and the End of Impressionism*. Chicago and London, 1984.

Lionello Venturi: *Cézanne. Son Art - Son Oeuvre. Catalogue Raisonné*. Paris, 1936.

Exhibition Catalogues

William Rubin (ed): *Cézanne. The Late Work*. Catalogue of an exhibition at the Museum of Modern Art, New York, the Museum of Fine Arts, Houston, and the Musée du Louvre, Paris, 1977.

Lawrence Gowing: *Cézanne. The Early Years 1859-1872*. Catalogue of an exhibition at the Royal Academy of Arts, London, 1988.

Richard Verdi: *Cézanne and Poussin: The Classical Vision of Landscape*. Catalogue of an exhibition at the National Gallery of Scotland, Edinburgh, 1990.

Sainte-Victoire. Cézanne. Catalogue of an exhibition at the Musée Granet, Aix-en-Provence, 1990.

General

Albert Boime: *The Academy and French Painting in the Nineteenth Century*. London, 1971.

A Day in the Country. Impressionism and the French Landscape. Catalogue of an exhibition at the Los Angeles County Museum of Art, the Art Institute of Chicago and the Grand Palais, Paris, 1984-1985.

Anthea Callen: *Techniques of the Impressionists*. London, n.d.

Claire Frèches-Thory & Antoine Terrasse: *The Nabis. Bonnard, Vuillard and their Circle*. Paris, 1990.

List of Illustrations

Colour Plates

1. Portrait of the Painter, Achille Emperaire
 c.1868-70. Oil on canvas, 200 x 122 cm. Musée d'Orsay, Paris

2. The Railway Cutting
 c.1869-70. Oil on canvas, 80 x 129 cm. Bayerische Staatsgemäldesammlungen, Munich

3. Melting Snow at l'Estaque
 c.1870. Oil on canvas, 73 x 92 cm. Fondation E.G. Bührle Collection, Zurich

4. The Feast (The Orgy)
 c.1870. Oil on canvas, 130 x 81 cm. Private Collection

5. The Temptation of St. Anthony
 c.1870. Oil on canvas, 54 x 73 cm. Fondation E.G. Bührle Collection, Zurich

6. The Black Marble Clock
 c.1870. Oil on canvas, 60 x 50 cm. Private Collection

7. A Modern Olympia
 c.1873-5. Oil on canvas, 46 x 55 cm. Musée d'Orsay, Paris

8. Dr. Gachet's House at Auvers
 c.1873. Oil on canvas, 46 x 38 cm. Musée d'Orsay, Paris

9. Still Life with Glass, Fruit and Knife
 c.1877-89. Oil on canvas, 46 x 55 cm. Private Collection, Paris

10. Self-Portrait
 c.1879-80. Oil on canvas, 33.5 x 24.5 cm. Oskar Reinhardt Collection, Winterthur

11. The Bridge at Maincy, near Melun
 c.1879-80. Oil on canvas, 58.5 x 72.5 cm. Musée d'Orsay, Paris

12. The Poplars
 c.1879-82. Oil on canvas, 65 x 81 cm. Musée d'Orsay, Paris

13. Three Women Bathing
 c.1879-82. Oil on canvas, 50 x 50 cm. Petit Palais, Paris

14. Madame Cézanne in the Conservatory
 c.1883-4. Oil on canvas, 92.1 x 73 cm. Metropolitan Museum of Art, New York

15. Portrait of the Artist's Son, Paul
 c.1885-90. Oil on canvas, 65.3 x 54 cm. National Gallery of Art, Washington

16. La Montagne Sainte-Victoire
 c.1885-7. Oil on canvas, 59.6 x 72.5 cm. Phillips Collection, Washington

17. Landscape with a Viaduct: Mont Sainte-Victoire
 c.1885-7. Oil on canvas, 65 x 81 cm. Havemeyer Collection, Metropolitan Museum of Art, New York

18. The Village of Gardanne
 c.1885-7. Oil on canvas, 92 x 74.6 cm. Brooklyn Museum, New York

19. The Jas de Bouffan
 c.1885-7. Oil on canvas, 60 x 73 cm. National Gallery, Prague

20. Chestnut Trees at the Jas de Bouffan
 c.1885-7. Oil on canvas, 73 x 92 cm. Minneapolis Institute of Fine Arts

21. The Bay of Marseilles, seen from l'Estaque
 c.1886-90. Oil on canvas, 80.8 x 99.8 cm. Art Institute of Chicago

22. Mountains seen from l'Estaque
 c.1886-90. Oil on paper, later mounted on canvas, 54 x 73 cm. National Museum of Wales, Cardiff

23. Mountains in Provence
 c.1886. Oil on canvas, 63.5 x 79.4 cm. National Gallery, London

Text Figures

5. Portrait of the Artist's Father
1866. Oil on canvas, 198.5 x 119.3 cm. National Gallery of Art, Washington

6. Paul Alexis Reading to Emile Zola
c.1869-70. Oil on canvas, 130 x 160 cm. Museu del Arte, São Paulo

7. Pissarro going off to Paint
c.1874-7. Pencil on paper, 20 x 11 cm. Cabinet des Dessins, Musée du Louvre, Paris

8. The House of the Hanged Man
1873-4. Oil on canvas, 55 x 66 cm. Musée d'Orsay, Paris

9. Victor Chocquet Seated
c.1879-82. Oil on canvas, 46 x 38 cm. Columbus Museum of Art, Ohio

10. Turn in the Road
c.1879-82. Oil on canvas, 60.5 x 73.5 cm. Museum of Fine Arts, Boston

11. Portrait of Gustave Geffroy
1895. Oil on canvas, 116.2 x 88.9 cm. Musée d'Orsay, Paris

Comparative Figures

12. Ingres: 'Emperor Napoleon I on his Imperial Throne'
1806. Oil on canvas, 260 x 163 cm. Musée de l'Armée, Palais des Invalides, Paris

13. The Rape
c.1867. Oil on canvas, 90.5 x 117 cm. Private Collection, on loan to the Fitzwilliam Museum, Cambridge

14. Veronese: The Wedding at Cana,
Oil on canvas. Musée du Louvre, Paris

15. Large Bathers
c.1896-7. Lithograph, 41 x 51 cm. Tate Gallery, London

16. Chardin: A Kitchen Table
Oil on canvas, 39.5 x 47 cm. Museum of Fine Arts, Boston

17. Manet: Olympia
1863. Oil on canvas, 130.5 x 190 cm. Musée d'Orsay, Paris

18. The House of Père Lacroix at Auvers
c.1873. Oil on canvas, 61 x 50 cm. Chester Dale Collection, National Gallery of Art, Washington

19. Denis: Homage to Cézanne
1900. Oil on canvas, 180 x 240 cm. Musée d'Orsay, Paris

20. Matisse: The Back II
c.1913-14. Bronze relief, 186.3 x 115 x 17.5 cm. Tate Gallery, London

21. Madame Cézanne with her Hair Let Down
c.1883-7. Oil on canvas, 62 x 51 cm. H.P. McIlhenny Collection, Philadelphia Museum of Art

22. Two Portraits of the Artist's Son
c.1877-8. Pencil on paper, 21 x 12 cm. Arthur Heun Fund, Art Institute of Chicago

23. The Valley of the Arc
c.1885-7. Pencil and watercolour on white paper, 34.7 x 53.1 cm. Art Institute of Chicago

24. La Montagne Sainte-Victoire
c.1888-90. Oil on canvas, 73 x 92 cm. Barnes Foundation, Merion

25. Avenue at the Jas de Bouffan
c.1884-7. Pencil on paper, 30.7 x 47.8 cm. Museum Boymans-van Beuningen, Rotterdam

26. The Sea at l'Estaque
c.1886-90. Oil on canvas, 65 x 81 cm. Private Collection, Paris

27. Basket of Apples
c.1895. Oil on canvas, 65 x 80 cm. Art Institute of Chicago

28. Still Life
c.1906. Watercolour, 47 x 62 cm. Estate of Henry Pearlman, New York

29. Les Arbres
c.1890-4. Watercolour. Princesse de Bassiano, Paris

30. Card Players
c.1890-2. Oil on canvas, 133 x 179 cm. Barnes Foundation, Merion

31. Bathers
c.1900-6. Watercolour, 18 x 25 cm. (Location unknown)

32. Male Bathers
1888-90. Oil on canvas, 54 x 65 cm. Private Collection, Paris

33. Veronese: The Supper at Emmaus
Oil on canvas, 290 x 448 cm. Musée du Louvre, Paris

34. Pistachio Tree in the Courtyard of the Château Noir
c.1900. Watercolour and pencil on paper, 54 x 43 cm. Art Institute of Chicago

35. Portrait of Vallier
c.1906. Oil on canvas, 65 x 54 cm. Private Collection

Portrait of the Painter, Achille Emperaire

c.1868-70. Oil on canvas, 200 x 122 cm. Musée d'Orsay, Paris

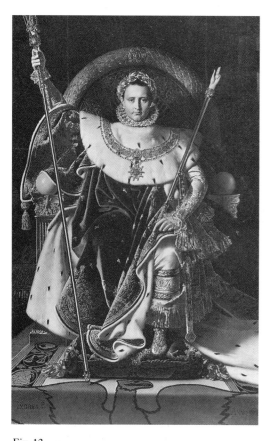

Fig. 12
Jean Auguste Dominique Ingres
Emperor Napoleon I on his Imperial
Throne
1806. Oil on canvas, 260 x 163 cm. Musée de l'Armée,
Palais des Invalides, Paris

This early portrait by Cézanne has been compared to Ingres' portrait of the *Emperor Napoleon I on his Imperial Throne* (Fig. 12), which would have been widely reproduced at the time. Furthermore, in a questionnaire he filled in during the late 1860s Cézanne's answer to the question 'What historical personage are you most drawn to?' was Napoleon. Along the top is stencilled the name and profession of Cézanne's friend - 'Achille Emperaire, Peintre'. Apart from the title, which puns on the similarity of the two names, both men are seated in large chairs, the one a patterned armchair (which appeared in Cézanne's earlier portrait of his father, Fig. 5), the other a magnificent throne. Whereas the scale of the Emperor's seat conveys a sense of the power that he commanded, Achille is literally dwarfed by his; his feet cannot reach the ground and must rest on a box, his hands seem useless. In contrast, Napoleon has been provided with an ornate velvet cushion for his feet and holds the sceptre of Charles V and the hand of justice of Charlemagne. Achille's hair and shoulder line both echo the line of the top of the chair; while Napoleon's golden wreath encircling his head is mirrored by the larger concave curve of his throne.

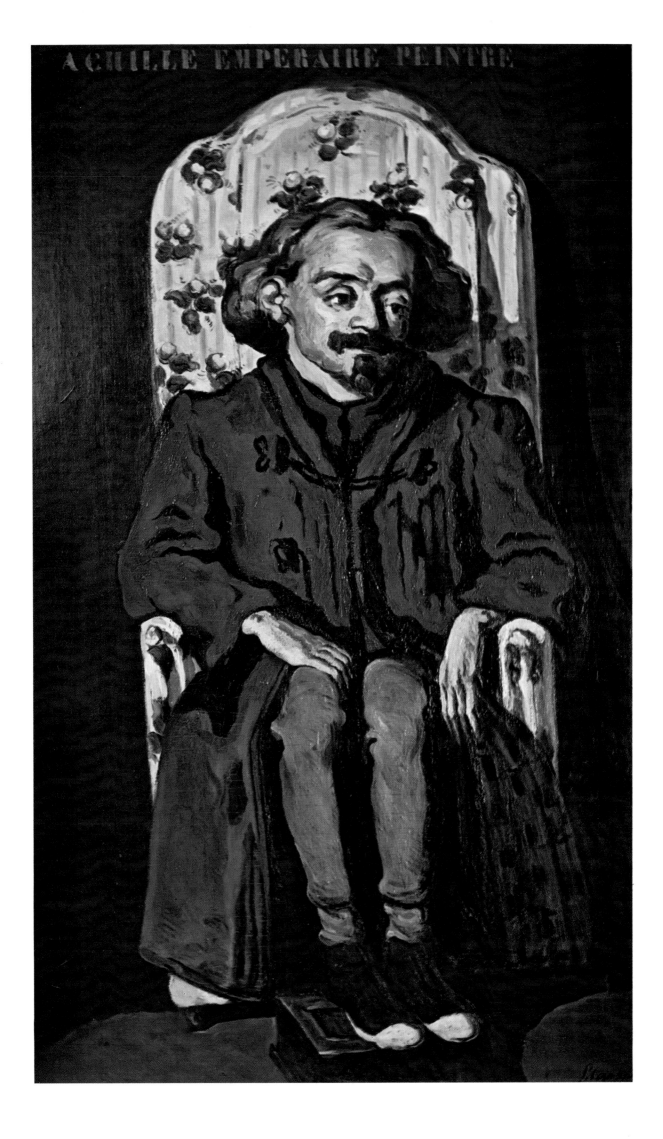

The Railway Cutting

c.1869-70. Oil on canvas, 80 x 129 cm. Bayerische Staatsgemäldesammlungen, Munich

This landscape and the next represent two early experiments in different types of landscape composition. This scene is composed on classical principles, already displaying a well-developed sense of equilibrium. In the centre of the picture is the main subject, a railway cutting with a signal box. This is flanked on the left by a house on a small hill; and balanced on the right by the distant form of the Mont Saint-Victoire. Although it appears in the background of *The Rape* (Fig. 13), this is the first time that Cézanne focuses on the mountain in its own right; he returned to the motif many times.

Cézanne's presentation of the subject is significantly ambivalent. The opening of this section of railway line between Aix and Rognac offered Cézanne travel and experience; yet he has chosen to separate himself, and us, from the object of our gaze by the horizontal bar of the garden wall of the Jas de Bouffan. Although he frequently includes the trappings of railway development in his landscapes (Plates 16 and 17), depicting viaducts and railway buildings, he never actually shows the trains themselves, puffing out clouds of steam, as did the Impressionists.

Fig. 13
The Rape
c.1867. Oil on canvas, 90.5 x 117 cm. Private Collection, on loan to the Fitzwilliam Museum, Cambridge

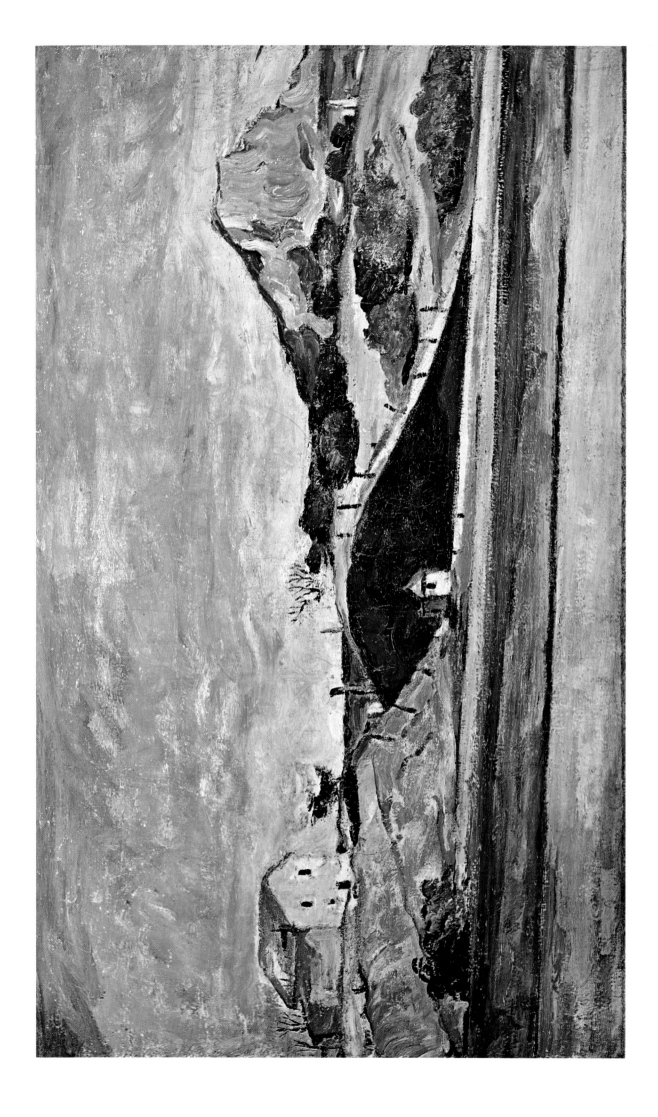

3 Melting Snow at l'Estaque

c.1870. Oil on canvas, 73 x 92 cm. Fondation E.G. Bührle Collection, Zurich

Cézanne spent the winter of 1870-1 with his mistress, Hortense Fiquet, in l'Estaque, a village on the coast near Marseilles, thus escaping conscription into the army for the Franco-Prussian War. The four known canvases that he painted there are all rather dark and gloomy, quite possibly reflecting his mood.

This composition is entirely different from the previous one; divided in two by a 'baroque' diagonal line of melting snow. The bottom left half seems completely unstable. The slurred brushstrokes are directional, emulating the downward slide of the snow, while the foliage and pointing angle of the lower-right roof all funnel us into a kind of vortex. At this point, the bright red roofs provide a safer element, introducing more solid architectural forms to hold the whole scene together, perhaps even to contain the landscape within the picture space.

Cézanne later told the dealer Ambroise Vollard: '...I worked a lot out-of-doors at Estaque. Except for that there was no other event of importance during the years 1870-1. I divided my time between the field and the studio'. This marks the beginning of Cézanne's adoption of the Impressionists' tenet of working before nature - *sur le motif.*

4 The Feast (The Orgy)

c.1870. Oil on canvas, 130 x 81 cm. Private Collection

The subject of this painting has recently been identified as the Feast of Nebuchadnezzar, the builder of Babylon, as described by Flaubert in his novel 'The Temptation of St. Anthony', which first appeared in serial form in 'L'Artiste' in 1856. Cézanne frequently 'borrowed' engravings reproduced in this journal, indicating that he was a regular reader. His friendship with Zola may have increased his liking for literary subjects and, certainly, the theme of revellers at a feast, with its long tradition of Renaissance bacchanals, Baroque love feasts and Rococo *fêtes galantes*, had all the right ingredients for the Salon audience of the 1870s. Couture's *The Romans of the Decadence*, shown first at the 1847 Salon and again at the 1855 World's Fair, had attracted a great deal of favourable criticism, and provided a recent precedent.

The style reveals Cézanne's taste for Veronese (Fig. 14), Rubens and Delacroix, whose works he copied daily in the Louvre. The sweeping mass of uplifted drapery, the mock columns and architectural detail, the decorative urns, the vivid blue of the sky and glowing colours of the robes around the impossibly tilted table all display Cézanne's debt to the Old Masters.

Fig. 14
Paolo Veronese
The Wedding at Cana
Oil on canvas. Musée du Louvre, Paris

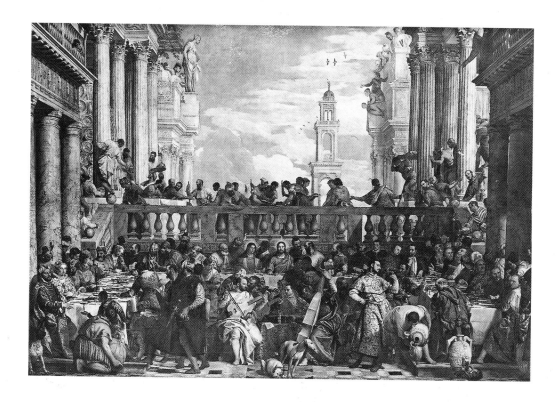

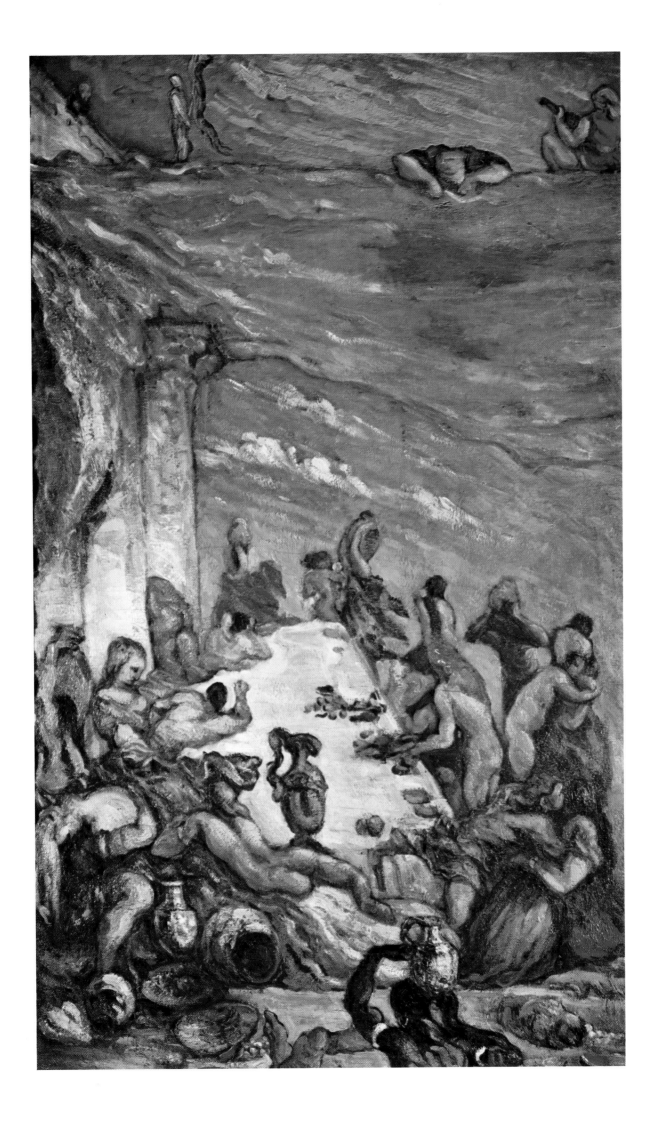

c.1870. Oil on canvas, 54 x 73 cm. Fondation E.G. Bührle Collection, Zurich

As in Plate 4, Flaubert's novel provided the initial inspiration for this work. However, the action of the title is relegated to the top left corner, rendering it almost incidental to the group of figures occupying the foreground. They separate Heaven, the saint, in the top corner from Hell, the fire, in the bottom right.

The principal focus, then, is on the three figures, with all the associations of the Three Graces and the Judgement of Paris. Studies in the Louvre had made Cézanne familiar with Rubens' *Apotheosis of Henry IV*, c.1631, on which the standing nude is based; Delacroix's *Michelangelo in his Studio*, 1850, which may have been the model for the pensive figure on the right; and Michelangelo's *Dying Slave*, for the temptress. This figure was used again some 25 years later (Fig. 15). Cézanne's unfinished *Portrait of Emile Zola*, c.1861-2, also bears a remarkable facial resemblance to this figure. Cézanne's friendship with the novelist was apparently an intimate one; and it is possible that the juxtaposition of male head on female body relates in some way to a private confusion in Cézanne's personal life. During this period he met Hortense Fiquet, who became his mistress and later his wife; but despite this association, Cézanne remained deeply uncomfortable in the presence of nude models throughout his life.

Fig. 15
Large Bathers
c.1896-7. Lithograph, 41 x 51 cm. Tate Gallery, London

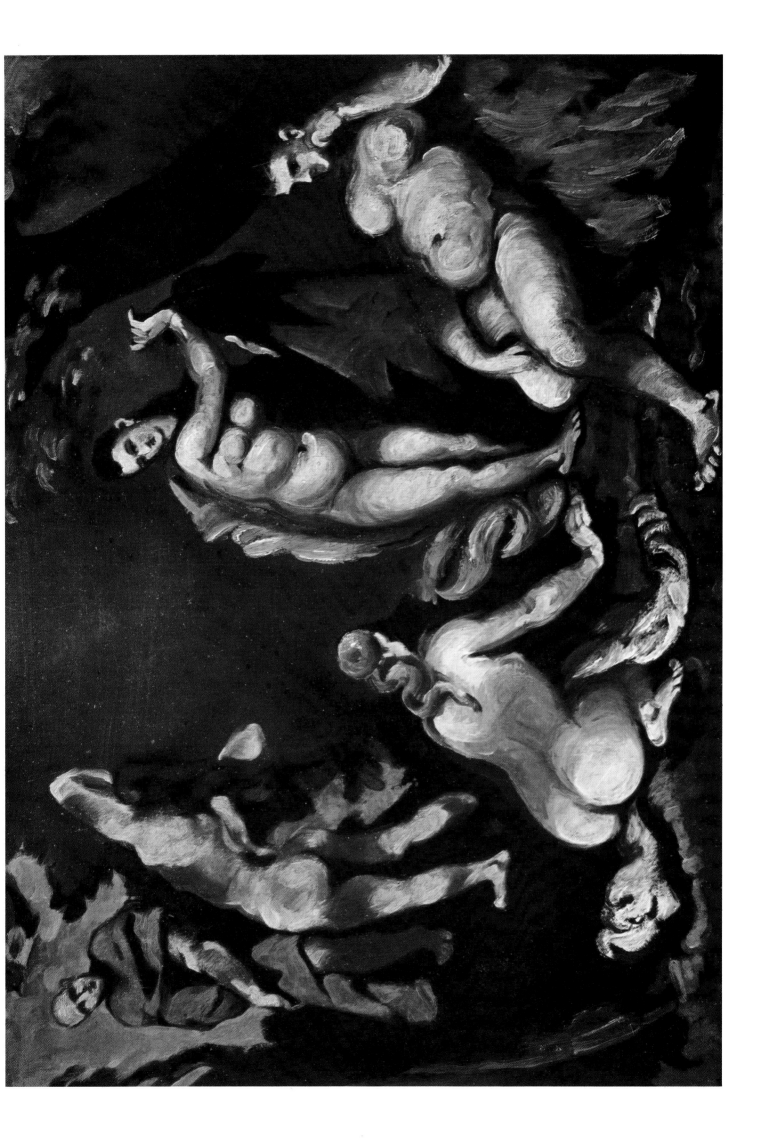

c.1870. Oil on canvas, 60 x 50 cm. Private Collection

This still life, which is almost a portrait of the clock, was commissioned by Zola, the owner of the piece. Various organic and manmade objects are grouped together on a table covered with a white cloth. Throughout the composition Cézanne contrasts shapes and colours: the heavy shadows in the draped folds of cloth; the round white face of the clock with its black square surround, reflected in the mirror to give it even more body and presence; the cylindrical stem of the vase with its petal-like mouth; the rich yellow lemon with the deep pinkish red of the conch shell; the relationship between the base of the urn and its mirrored reflection; and between the round coffee cup and square container perched on the edge of the table.

In 1869 the La Caze Bequest of still lifes by Jean Baptiste Chardin entered the Louvre's collection. Until then, such subjects had been regarded as a less important genre of painting by the French art establishment than, for example, historical or religious scenes. The undoubted quality of Chardin's work (Fig. 16), however, drew Cézanne's attention to the potential of such compositions.

Fig. 16
Jean Baptiste Chardin
A Kitchen Table
Oil on canvas, 39.5 x 47 cm. Museum of Fine Arts, Boston

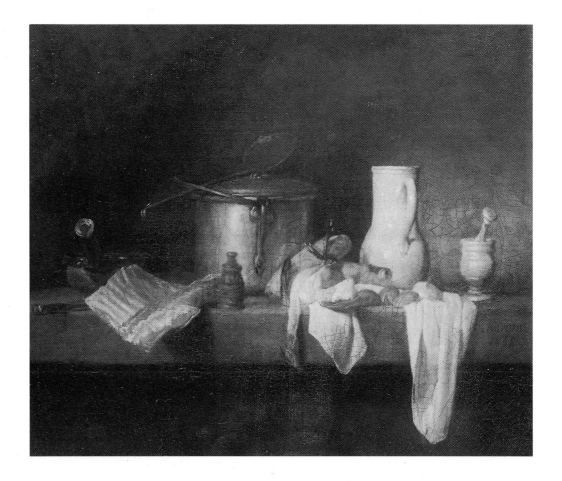

7 A Modern Olympia

c.1873-5. Oil on canvas, 46 x 55 cm. Musée d'Orsay, Paris

Cézanne's continuing acquaintance with the Impressionists prompted him to paint this reworking, or 'modernization' of Manet's controversial entry for the 1863 Salon (Fig. 17). Just as Manet reworked aspects of the painting on which his own was based, Titian's *Venus of Urbino*, 1538, exchanging red curtains for green and green bed for red, faithful dog for Baudelairean cat, symbol of promiscuity; so Cézanne plays on oppositions between and contrasts with his sources. Manet's wrapped bouquet of carefully arranged flowers becomes an exuberant profusion in a magnificent ornamental urn. The arching cat makes way for a reverent lapdog with red ribbon. The black maid has been given the much more active task of revealing the 'modern Olympia', rather demurely curled up, to her admirer, clearly recognizable from the shape of his head as Cézanne himself. In Manet's painting, only the open door in the background and the offering of flowers hint at an audience; here, the male observer allows us to participate in the spectacle. Our engagement with Manet's painting is via the direct confrontational gaze of Olympia herself; in Cézanne's we are invited by the maid and allowed entry by means of the diagonal line of the sofa.

Fig. 17
Edouard Manet
Olympia
1863. Oil on canvas, 130.5 x 190 cm. Musée d'Orsay, Paris

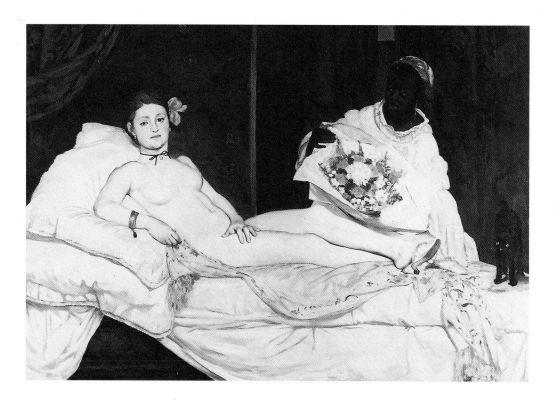

c.1873. Oil on canvas, 46 x 38 cm. Musée d'Orsay, Paris

Fig. 18
The House of Père Lacroix at Auvers
c.1873. Oil on canvas, 61 x 50 cm. Chester Dale
Collection, National Gallery of Art, Washington

The experience of painting with Pissarro in Pontoise and Auvers influenced Cézanne's style and technique enormously. The violent, erotic scenes of the previous decade gave way to a gentler, more contemplative approach to nature and to the rest of his subject matter (Fig. 18). He respected the work and advice of Pissarro, and some of their scenes painted from the same viewpoint share common aspects. His attitude to the countryside, though, was never akin to Pissarro's socialist vision of peasants working harmoniously in a Georgic landscape; indeed he hardly ever shows any sign of life at all. Whereas Sisley and Pissarro populate their village streets, Cézanne's are empty.

This view is of a bend in the road leading to the tall, peculiarly shaped house of Dr. Gachet, Cézanne's friend and patron. This device of the meandering road is one he uses frequently; it creates depth and at the same time focuses attention on the centrally placed house, the verticals and horizontals of which create the basic solidity of the composition (Fig. 10). The small cloud at the top right is given the same shape as the windows of the house, a device borrowed from Poussin and used to link together different pictorial elements.

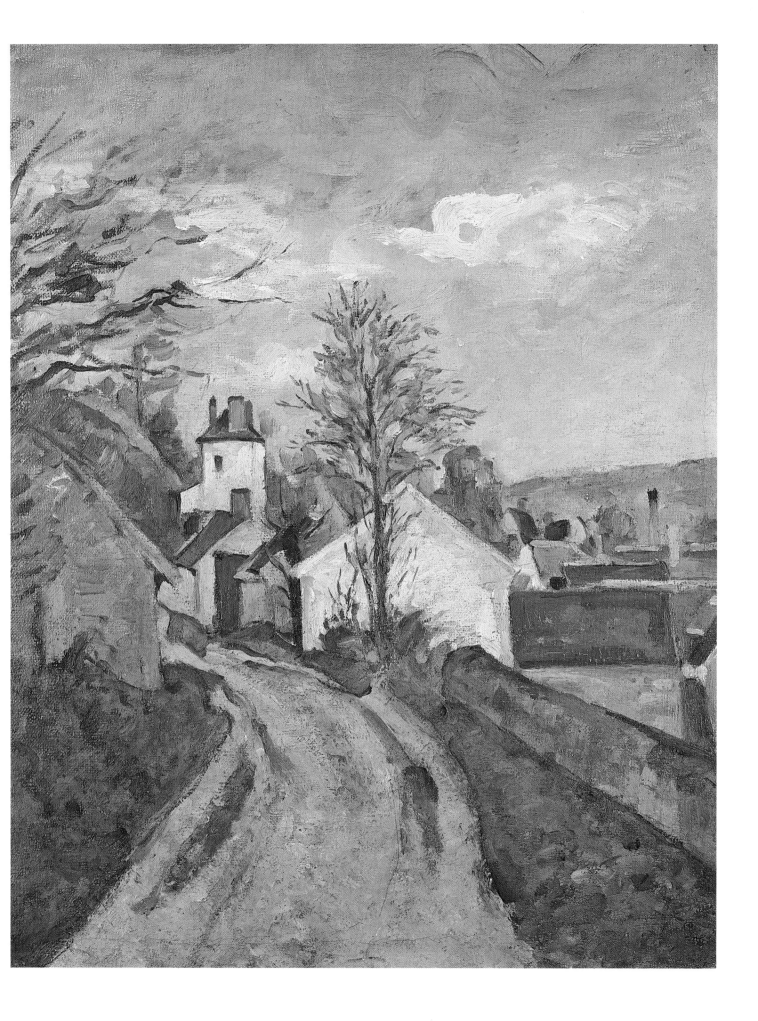

c.1877-89. Oil on canvas, 46 x 55 cm. Private Collection, Paris

Cézanne's unease with naked models meant that many of his experimental works were still lifes, which could be ordered in any design he chose and pondered over for hours. After the rather formal frontality of his early still lifes (see Plate 6), he began to take a slightly higher viewpoint that afforded more visual interest, allowing him to look into the vases, bowls and glasses of his arrangements.

This group of objects has clearly been manipulated by the artist in his exploration of the relationship of the objects to each other; the glass and bowl do not sit centrally on their bases, and the ellipses are not true. Again, he uses a horizontal line, in this case the table top, to stabilize the elements. As Maurice Denis wrote later about Cézanne's paintings: 'They were absurd to us at that time, because they were too rich to be easily intelligible'.

This painting was regarded with some importance; Gauguin included it in the background of his *Portrait of Marie Henry*, 1890, and Denis made it the focal point of his tribute, *Homage to Cézanne* (Fig. 19), surrounded by admirers including Redon, Vuillard, Vollard, Serusier and Bonnard.

Fig. 19
Maurice Denis
Homage to Cézanne
1900. Oil on canvas, 180 x 240 cm. Musée d'Orsay, Paris

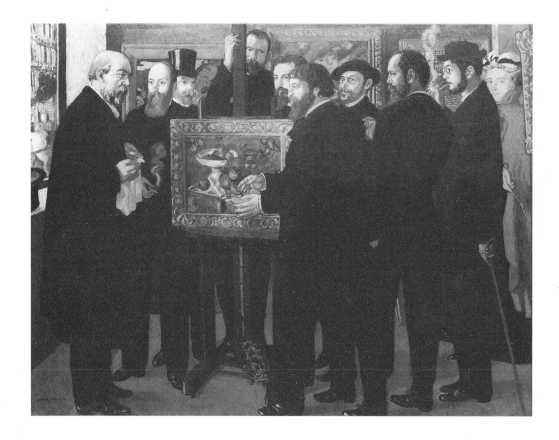

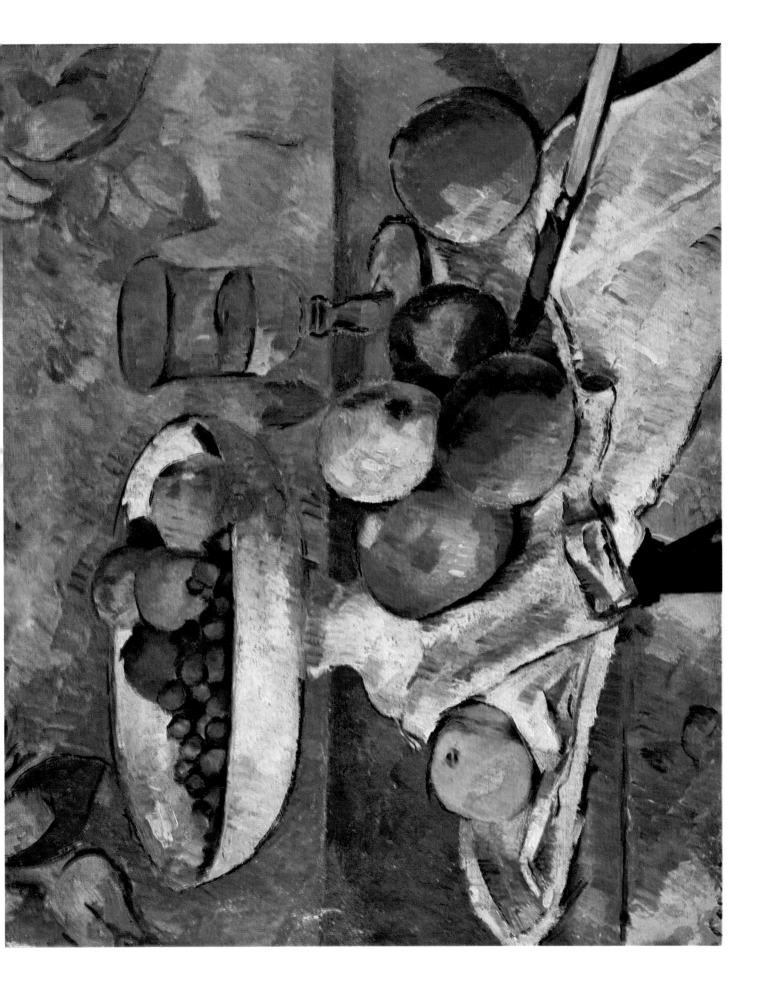

10 Self-Portrait

c.1879-80. Oil on canvas, 33.5 x 24.5 cm. Oskar Reinhardt Collection, Winterthur

Cézanne made over 20 self-portraits, perhaps at least partly because he painted so slowly that few sitters, other than his wife, were prepared to sit for so many hours. Ambroise Vollard, for instance (see Plate 41), attended 114 sittings before Cézanne abandoned the project, unsatisfied with his progress.

As usual in his portraits (see Plates 15 and 37 for example), Cézanne's facial expression gives no indication of mood or personality. His sitters tend to have rather blank faces, or at least a reserve; whether this is through boredom or design is unclear. Instead he concentrates on achieving a unified picture surface by using a single type of brushstroke, diagonally slanting, which is applied evenly across the canvas, whether depicting face, hair, clothes or background. Only the bottom lefthand corner remains unfinished, with the original thin wash of colour used to establish the composition still showing. Similarly, he uses touches of the same colours in different areas of the portrait, again to create a unification. The dabs of green underneath his jacket collar reappear on his forehead, in his beard and on the background wall. This 'constructive' stroke is one that Cézanne developed and applied to his work in all subjects.

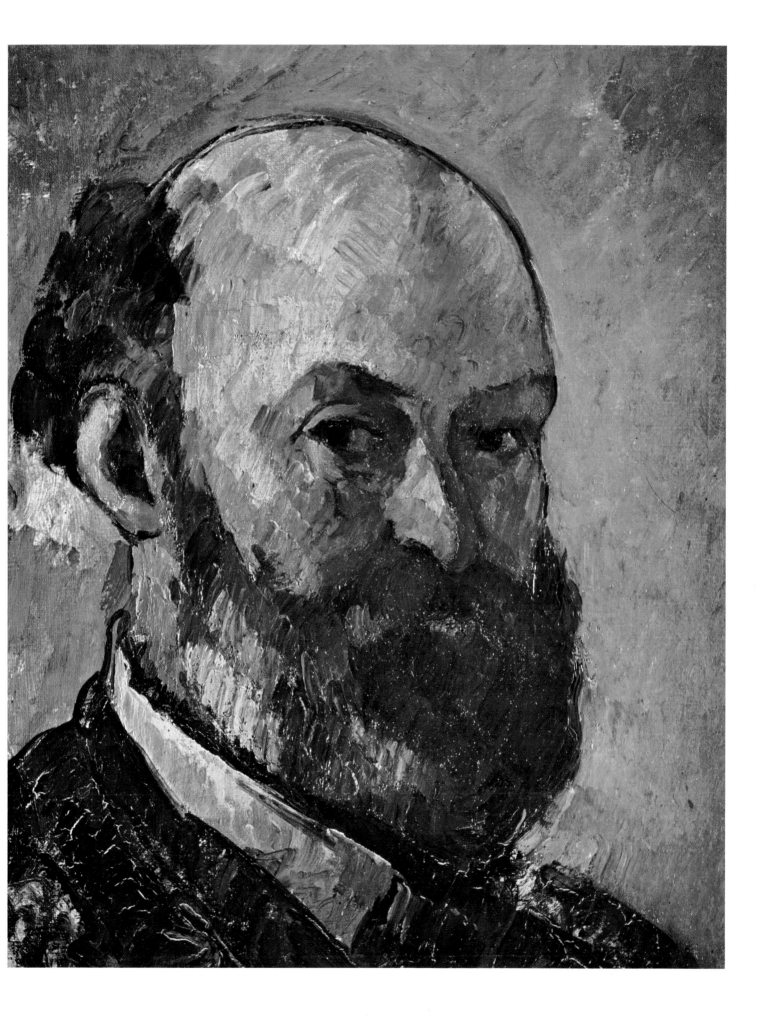

11 The Bridge at Maincy, near Melun

c.1879-80. Oil on canvas, 58.5 x 72.5 cm. Musée d'Orsay, Paris

52

The constructive brushstroke is clearly apparent in this landscape. The same rectangular touches are used throughout, so that Cézanne indicates the different types of surface texture by use of colour, rather than by changes in technique. Only in the water and foliage are the individual marks slightly fudged. This is also an early example of Cézanne's 'flattening' of the scene before him. He ignores aerial perspective, in which colours become paler as they fade into the distance - why, for example, distant mountains appear blue - treating all ranges of depth with equal intensity of colour.

The subject is typical: a single motif with an inbuilt structure ideal for Cézanne, who always sought pattern and order in nature. The vertical tree trunks are contrasted with the repeating horizontals of the old wood and stone bridge; while the reflections of the arches and diagonals of branches, ramp and house roof create more visual interest. This solidity of structure and treatment gives the landscape a feeling of timelessness - no ripples mar the surface, no wind stirs the leaves - a continuing characteristic of Cézanne's oeuvre.

12　The Poplars

c.1879-82. Oil on canvas, 65 x 81 cm. Musée d'Orsay, Paris

The Poplars again displays a deliberate seeking out of a naturally occurring landscape composition to which Cézanne could apply himself. Nearly all points of architectural interest have been removed, only a small section of garden wall shows through a gap in the trees. Instead, the artist concentrates on the contrast between the spindly upright poplars and the mass of undefined grass in the foreground and foliage along the skyline, using diagonal strokes of brilliant green. The treatment of the sky is more cursory, with patches of cream-primed canvas showing through.

The view is probably taken from just outside the park of the Château des Marcouvilles in the village of Les Patis. Pissarro had worked in the same area during the early and middle 1870s, painting one picture from approximately the same position. These early examples remained in Pissarro's possession, and Cézanne undoubtedly had these in mind when he painted his own version.

13 Three Women Bathing

c.1879-82. Oil on canvas, 50 x 50 cm. Petit Palais, Paris

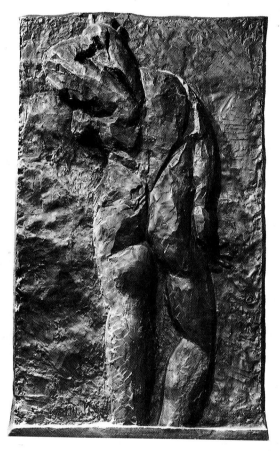

Fig. 20
Henri Matisse
The Back II
c.1913-14. Bronze relief, 186.3 x 115 x 17.5 cm.
Tate Gallery, London

Cézanne's memories of boyhood days spent swimming in the rivers of the Aix countryside were the initial inspiration for his many scenes of naked figures in a landscape, together with innumerable examples from the Old Masters in the Louvre, such as Titian's *La Fête Champêtre*. The subject was also popular with contemporary Salon painters. Joseph-Victor Ranvier's *L'Enfance de Bacchus*, bought by the State from the 1865 Salon, uses the excuse of mythology to depict flimsily clad females frolicking in a river with the young god.

Cézanne's figures are not, however, titillating or erotic. Their rather large, clumsy forms are peculiarly sexless, with their great broad backs and solid limbs. Henri Matisse bought this painting with part of his wife's dowry in 1899, and it is tempting to see in this a source for his sculptural reliefs of backs, which gradually become more and more abstract (Fig. 20), in the same way that Cézanne's reworkings of the bathers theme make the figures increasingly androgynous.

The surrounding features of the landscape have been appropriated by the needs of composition; framing trees lean in from both sides of the painting to focus our attention on the group of figures.

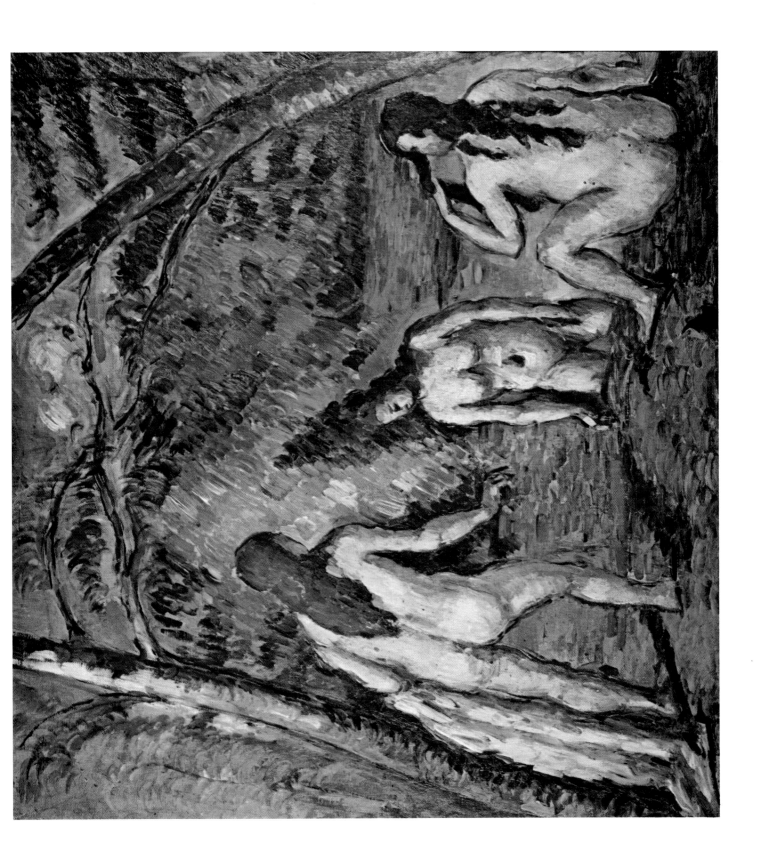

c.1883-4. Oil on canvas, 92.1 x 73 cm. Metropolitan Museum of Art, New York

Fig. 21
Madame Cézanne with her Hair Let Down
c.1883-7. Oil on canvas, 62 x 51 cm. H.P. McIlhenny
Collection, Philadelphia Museum of Art

As Rewald notes, 'Hortense's only contribution to her husband's artistic life as an artist was in posing for him repeatedly without moving or talking'. This is perhaps one of the most sympathetic portraits of Hortense who, despite the title since given to the portrait, did not become Cézanne's wife until 1886. Although her face is expressionless as always (Fig. 21), the choice of location and the softer colouring create a certain gentleness.

Hortense wears a black dress with a tight bodice. Touches of green, blue and brown relieve the sombreness of her costume, and also serve to relate her to the surrounding leaves and tree. The pink of her ears, nose, cheeks and lips is repeated in the flowers and highlights on the branches of the tree behind her; she is made to empathize with nature.

Although the painting is unfinished, with sections of the canvas only roughly brushed in, Cézanne has fully worked out the composition. The diagonal outlines of her skirt are picked up in the wall behind her and in the angle of the branches; the near-perfect oval of her face compares with the cylindrical pot, modelled in patches of colour.

Unusually, Cézanne here gives an impression of sunlight through the warm earth tones. His landscapes tend to be lit with a uniform brightness, since he was not, unlike the other Impressionists, interested in the fleeting effects of the weather.

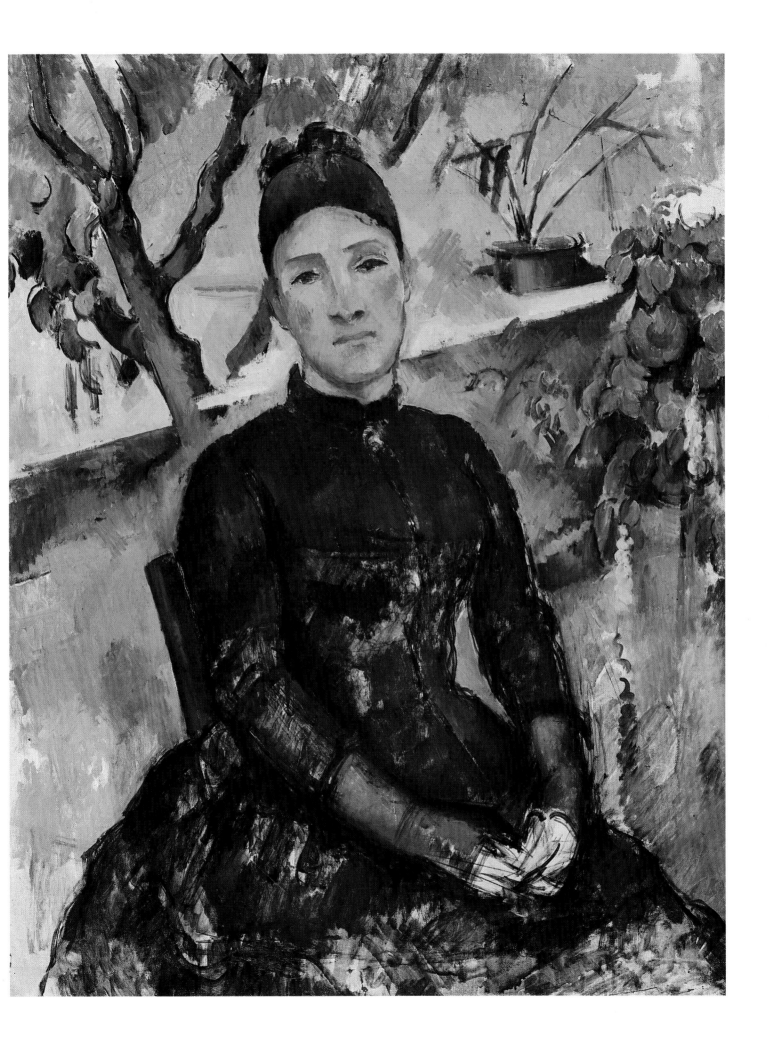

15 Portrait of the Artist's Son, Paul

c.1885-90. Oil on canvas, 65.3 x 54 cm. National Gallery of Art, Washington

Fig. 22
Two Portraits of the Artist's Son
c.1877-8. Pencil on paper, 21 x 12 cm. Arthur Heun
Fund, Art Institute of Chicago

Cézanne's son was born on 4 January 1872, and was an occasional sitter for his father (Fig. 22). He was about 15 years old at the time of this portrait. Although the artist has, as usual, refrained from revealing much of his son's personality, the young lad does have a certain jauntiness in his expression.

The pose chosen is one of Cézanne's favourites, with the body turned slightly from full frontal, so that the shoulders offset the background wall behind him, which is parallel to the picture plane. This device immediately creates depth in the picture, which otherwise tends towards flatness, in the patterned paper and edge of the decorative screen that juts in from the right, with no real indication of its spatial relationship to the other elements in the picture.

The young Paul is shown wearing everyday clothes, he has not dressed up for the occasion. As in other portraits (see Plates 30 and 37), Cézanne aligns part of the sitter's form with another feature in order to anchor him more firmly into the composition. Here, the crown of the hat has been set directly in line with the outline of the head below, thus making the hat actually too small to fit properly.

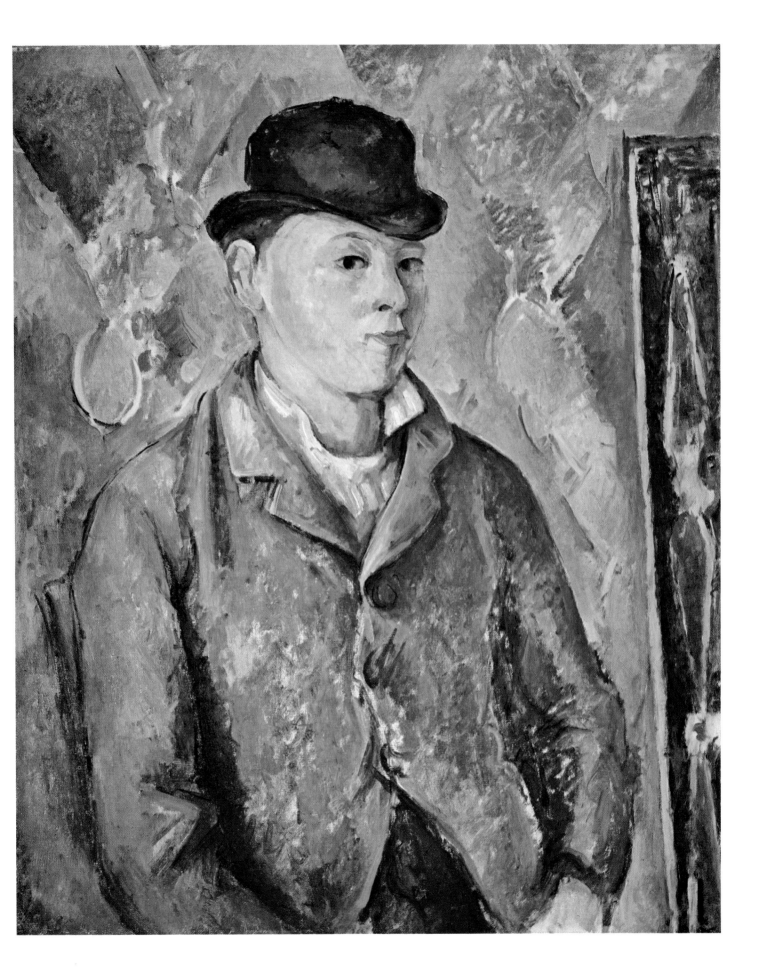

c.1885-7. Oil on canvas, 59.6 x 72.5 cm. Phillips Collection, Washington

This view of the Mont Sainte-Victoire, and that in the accompanying watercolour (Fig. 23), is taken from the south-west of Aix, probably from Bellevue, where Maxime Conil, Cézanne's brother-in-law, had bought an estate in 1881. From an elevated position the picture surveys the scene across the Arc valley towards the mountain. Comparisons with photographs show that Cézanne has brought the Mont Sainte-Victoire considerably closer, making it a more impressive motif.

This painting is an excellent demonstration of Cézanne's study of Poussin. In the best classical tradition, he frames the scene with tree trunks on either side. A strong diagonal in the line of the road leads us into the landscape; while the horizontal viaduct prevents our gaze from rushing unchecked into the distance. Furthermore, Cézanne follows the skyline of the mountain and surrounding hills with the undulating branches, even repeating the concave curve of the peak.

Cézanne has also used a favourite device to link foreground with background (see also Plates 17 and 40). The foliage of the lefthand tree at one point becomes indistinguishable from the mountain ridge behind it.

Fig. 23
The Valley of the Arc
c.1885-7. Pencil and watercolour on white paper,
34.7 x 53.1 cm. Art Institute of Chicago

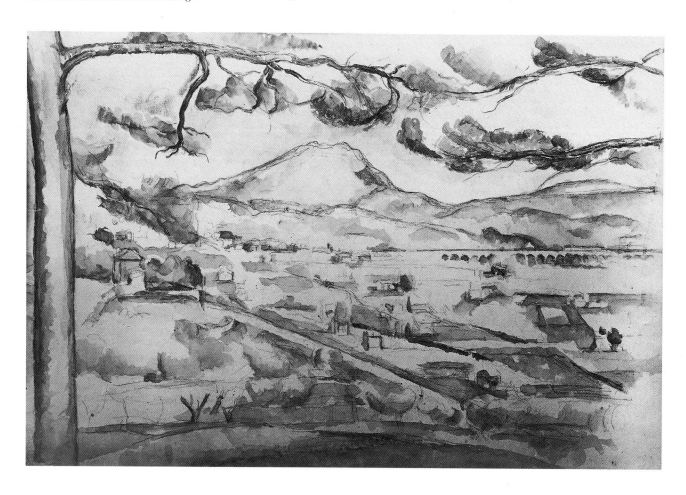

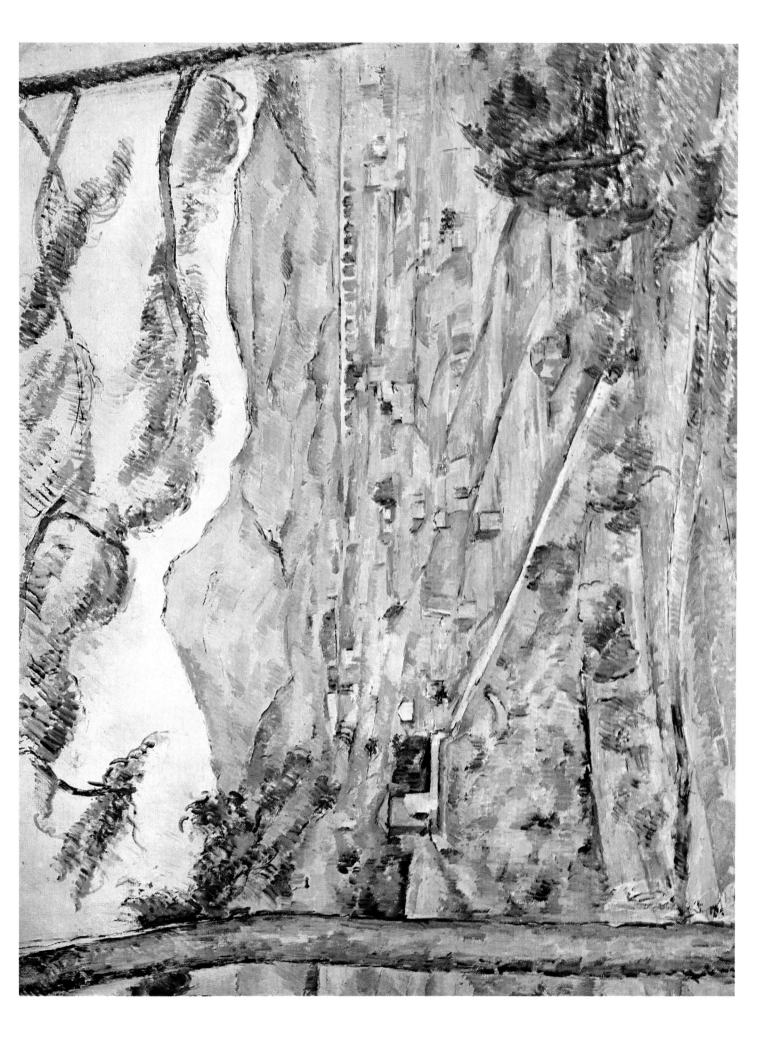

Landscape with a Viaduct: Mont Sainte-Victoire

c.1885-7. Oil on canvas, 65 x 81 cm. Havemeyer Collection, Metropolitan Museum of Art, New York

The linking of fore- and background is used again in this picture. The central tree is the key to this composition. It rises from the vegetation nearest to us at the bottom of the picture, passes through the middle distance of the valley where it intersects with the railway viaduct at almost the dead centre of the canvas, and then overlaps with the mountain range and sky, the shape of its foliage reflecting that of the Mont Sainte-Victoire. On the left of the tree, the extension of the viaduct 'becomes' a branch to support the unattached clump of foliage, in a remarkable reconciliation of modern development with nature. The slim branch on the right of the tree points up towards the viaduct, taking on the same colour as it does so, before sloping down to parallel the diagonal of the road.

The patchwork of the fields in the Arc river valley and the small buildings with their sloping roofs dotted across it allow Cézanne to punctuate the recession into the distance. He made two drawings of this scene, a watercolour and a less finished oil, no doubt to experiment with the difficult problem of the centrally placed tree. Fig. 24 shows how Cézanne later began to concentrate on the mountain alone.

Fig. 24
La Montagne Sainte-Victoire
c.1888-90. Oil on canvas, 73 x 92 cm. Barnes Foundation, Merion

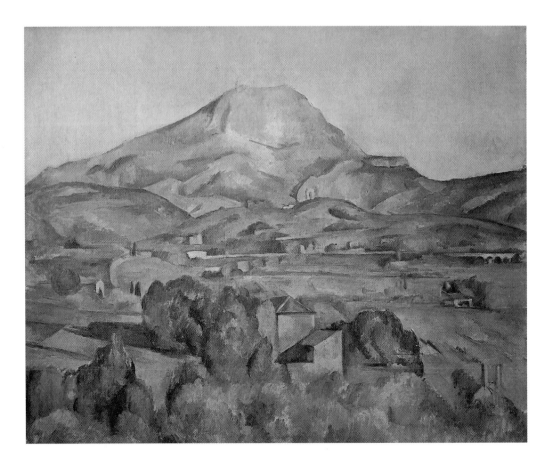

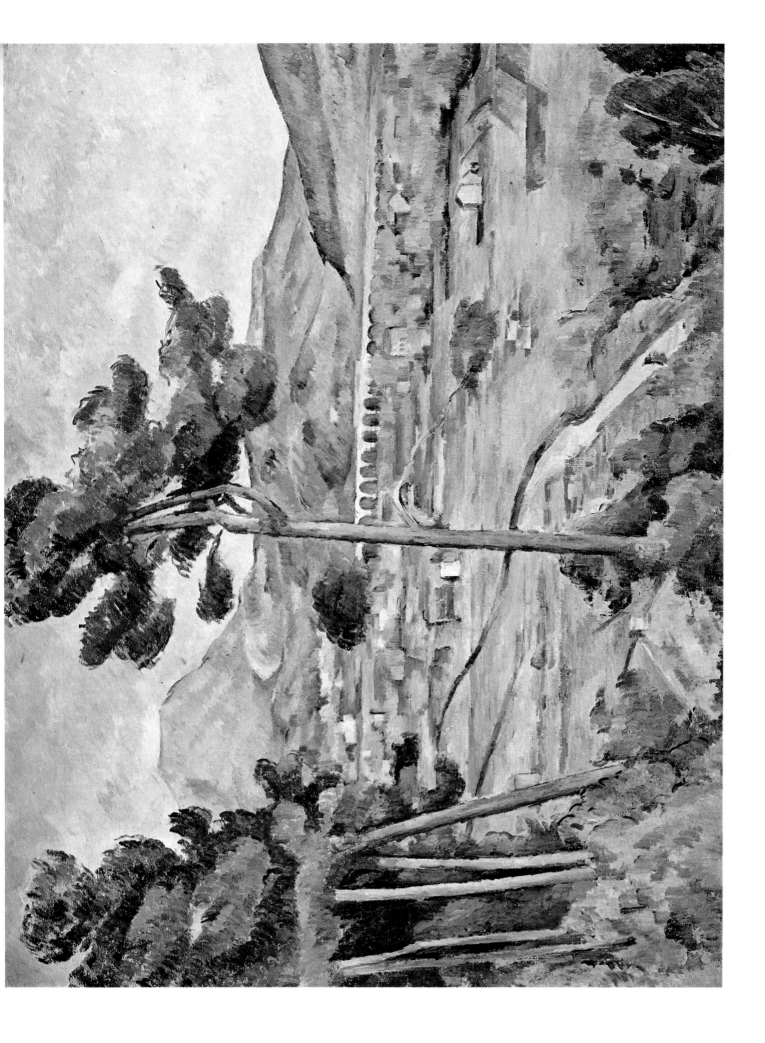

18 The Village of Gardanne

c.1885-7. Oil on canvas, 92 x 74.6 cm. Brooklyn Museum, New York

During the late 1880s Cézanne spent little time in Paris. He was deeply hurt by Zola's novel 'L'Oeuvre', published in March 1886, and the continual rejections from the Salon depressed him so much that he stopped submitting works for some years. In addition, there was good reason to stay in Provence. In April 1886 Cézanne finally married Hortense, perhaps provoked by Zola's apparent rejection. No sooner was he reconciled with his parents by making his liaison official, than his father died in October of the same year. Cézanne inherited the Jas de Bouffan, and for the first time his family could join him there.

In August and September 1885, and for much of 1886, Cézanne rented a house in Gardanne, a village near Aix. This picture shows his experimentation with the architecturally solid blocks of buildings and masses of foliage and the awareness of the flatness of the canvas surface itself. The warm terracotta and pink tones of the houses advance out of the picture; while the cool green and blue foliage recedes, creating a tapestry effect. The bottom right corner is left unfinished, leaving part of the canvas clearly visible.

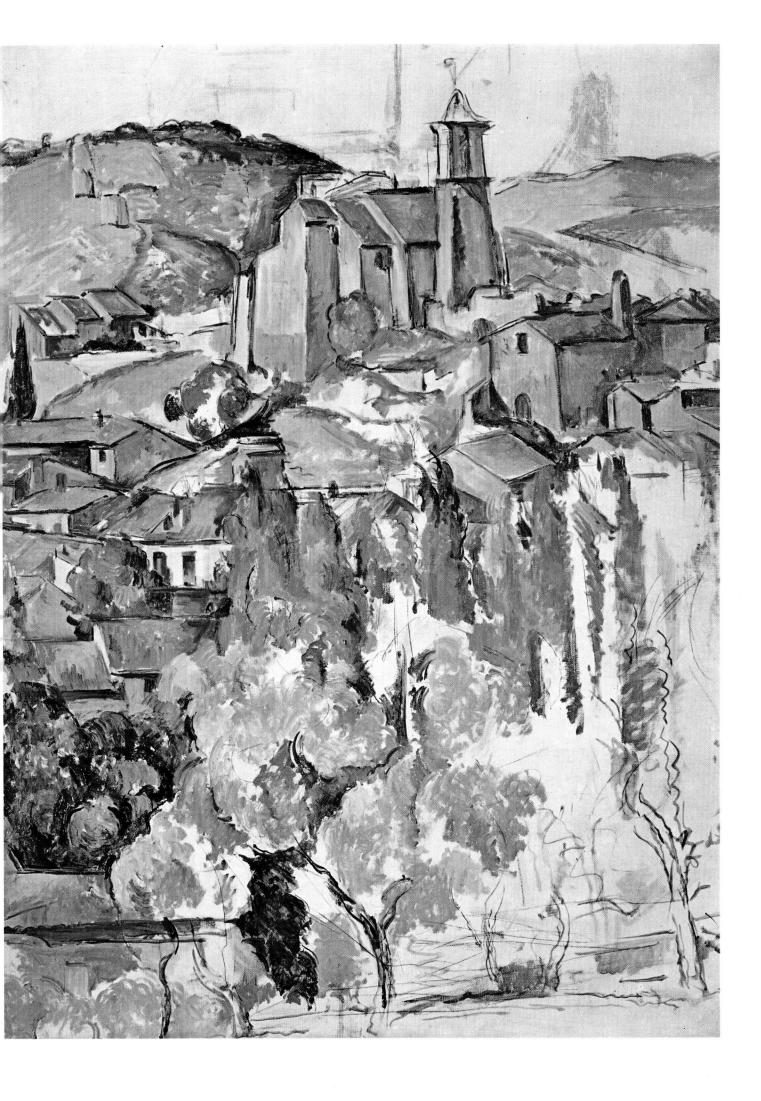

19 The Jas de Bouffan

c.1885-7. Oil on canvas, 60 x 73 cm. National Gallery, Prague

While living in Aix, Cézanne painted many pictures in and around the grounds of the family home. Unlike his other paintings of houses in a village (see Plates 8, 18 and 21), the windows are open, allowing some engagement with the interior. On the other hand, the space inside is blacked in, and the garden wall shuts us off from immediate access to the house, as it did the railway cutting in Plate 2. A photograph taken from the same spot reveals that Cézanne has manipulated the scene before him considerably; in reality the wall slopes in at a sharper angle, pointing at the house, rather than barring it off.

The most striking aspect is the tilting of the house, inclined on an axis of its own and thus setting up a tension with the skyline, wall and other buildings. The parallel bands of windows and shutters reinforce this inclination to the left. The area of green in front of the house is on the same axis, relating it to the house.

Chestnut Trees at the Jas de Bouffan

c.1885-7. Oil on canvas, 73 x 92 cm. Minneapolis Institute of Fine Arts

As in the painting of *The Poplars* (Plate 12), Cézanne has evidently chosen a view with inherent natural geometry. Chestnut trees are arranged in pairs rhythmically across the canvas, the distance between each pair matched by the parallels of path and wall running perpendicularly to them. Similar pairings occur in the two black squares representing entrances to an outhouse; in the two rounded trees immediately above them; and in the repetition of the shape of the larger part of the building on the left in its small extension.

The season is winter or early spring, when the lack of leaves on the trees allows for a great patterning of branches, breaking up the large expanse of canvas given over to the sky. Despite the somewhat oriental effect this creates, Cézanne thought little of the Japanese prints that so attracted Degas, Van Gogh and the Symbolists in particular. His flattening of landscapes was the result of a desire not for pattern, but to unify the pictorial elements. Cézanne painted this avenue from a number of different viewpoints (see Fig. 25).

Fig. 25
Avenue at the Jas de Bouffan
c.1884-7. Pencil on paper, 30.7 x 47.8 cm. Museum Boymans-van Beuningen, Rotterdam

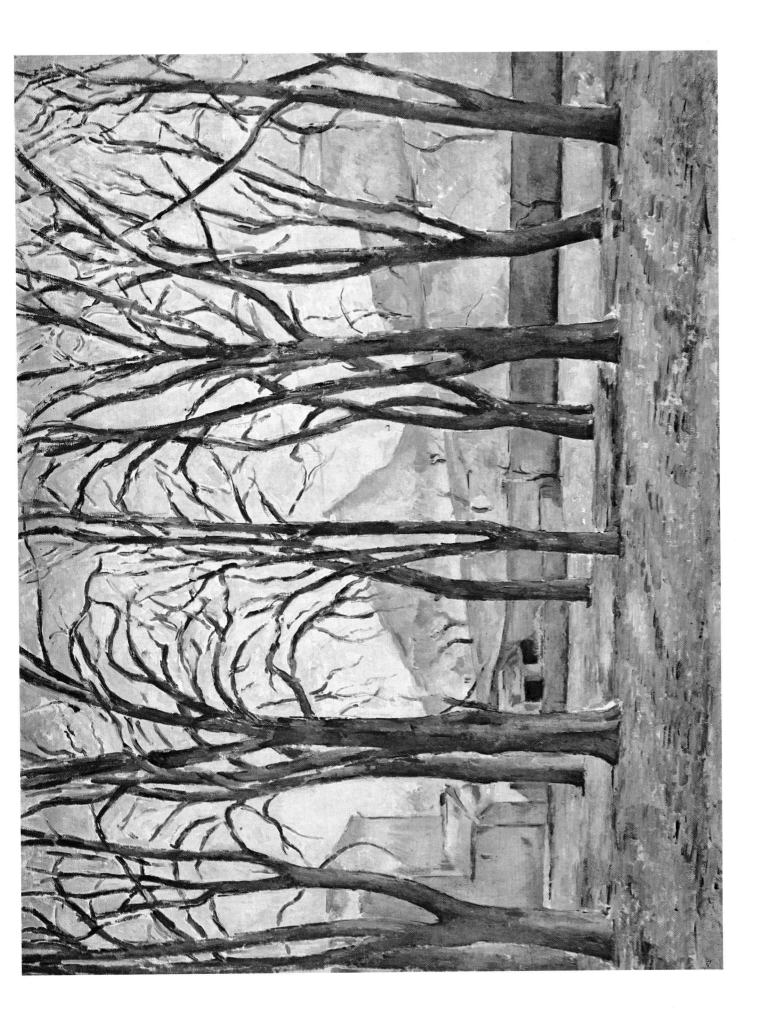

c.1886-90. Oil on canvas, 80.8 x 99.8 cm. Art Institute of Chicago

Cézanne regarded l'Estaque with much affection after his first visit in 1870, and during the 1880s, when the strains of Parisian life became too much, he frequently retreated to the seaside village. The scenes he painted there (see Fig. 26) reveal something of his nostalgic attitude towards the area. This view has a certain timelessness – no fishing boats on the water, no people in the streets – and the only indications of modern life, the chimneys and smoke, are turned into compositional devices that lock the picture together. The puff of smoke points towards the far shore in a diagonal line taken up by the jetty of Marseilles, linking nearby buildings with distant mountains; the tallest chimney is banded in warm light colours at the base changing to dark cool colours at the top, mirroring the passage from land to sea vertically up the picture plane.

Indeed, Cézanne did not return in the 1890s, complaining about '...the once so picturesque banks of l'Estaque. Unfortunately what we call progress is nothing but the invasion of bipeds who do not rest until they have transformed everything into hideous quais with gas lamps - and, what is worse - with electric illumination. What times we live in!'

Fig. 26
The Sea at l'Estaque
c.1886-90. Oil on canvas, 65 x 81 cm. Private Collection, Paris

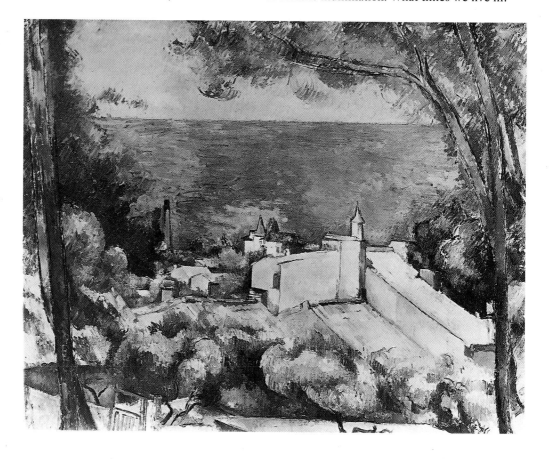

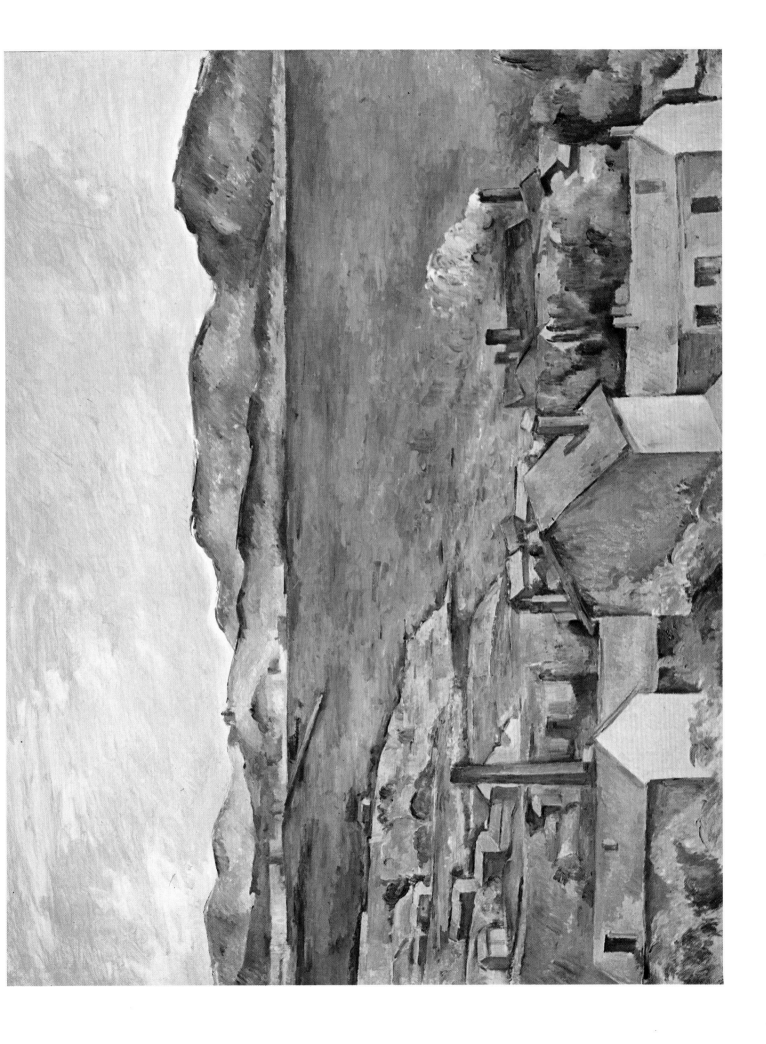

22 Mountains seen from l'Estaque

c.1886-90. Oil on paper, mounted on canvas, 54 x 73 cm. National Museum of Wales, Cardiff

This painting, looking inland towards the *chaîne de l'Estaque* which separates the coast from Aix, was painted on cream coloured commercially prepared paper, presumably pinned to a drawing board and later mounted on canvas. In places the cream background is allowed to show through as a colour in its own right. The unfinished nature of the picture, and the bold execution, with broad strokes of pure colour, suggest that the work was done entirely in the open air, *sur le motif.*

This accounts for the simplification of the scene. The composition is based on the succession of interlocking spurs, a series of arcs repeated in the curve of small trees at the base of the picture and in the mountain skyline at the top. The house immediately below echoes the peak in colour and shape. At the very centre is a small, rather insignificant brown tree, forming a kind of negative focus. As in *The Village of Gardanne* (Plate 18), Cézanne contrasts the advancing quality of the warm ochres and oranges with the receding patches of green and blue. The resulting two-dimensionality is what attracted Gauguin to the picture, who not only bought it but made a copy of it on a fan.

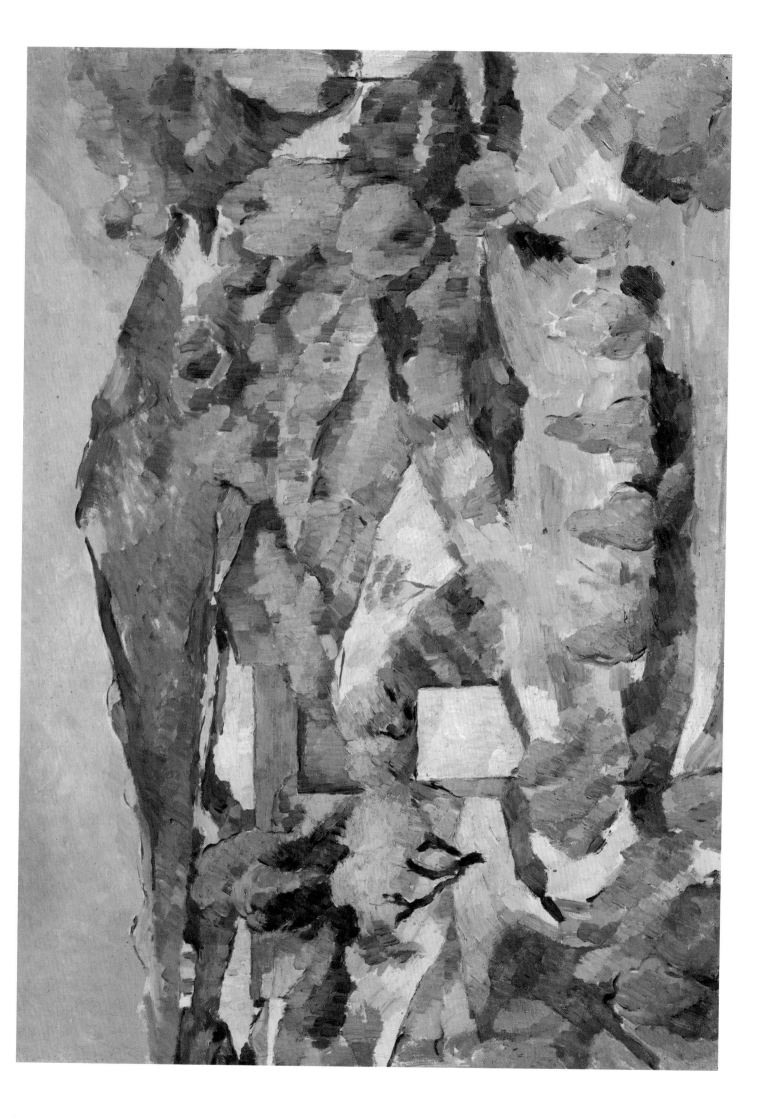

23 Mountains in Provence

c. 1886. Oil on canvas, 63.5 x 79.4 cm. National Gallery, London

In contrast to the last painting, this landscape is highly organized and must have been painted mainly in the studio. Paint cross-sections have revealed much preliminary drawing, first in graphite pencil and then in fine lines of greyish-blue paint, clearly visible in the painting, especially along the skyline. Both this careful observation of form and the use of the cream primed canvas as a colour in its own right recall the view of Gardanne (Plate 18).

Cézanne also displays his knowledge of the colour theories adopted by the Impressionists, those of Goethe, Chevreul and others. The shadows in the rocks are modelled not tonally - that is, in black through to white - but by using complementary colours. The orange-red rocks become deep grey-blue-violet in shadow, with only very sparing touches of black. The fields on the sloping hillside in the background are made up of patches of green and yellow, placed next to highlights of red and deep blue. The visual excitement that this optical device produces is Cézanne's answer to the problem of painting sunlight. He realized that he could not reproduce it directly, but must rather seek to represent it by other means.

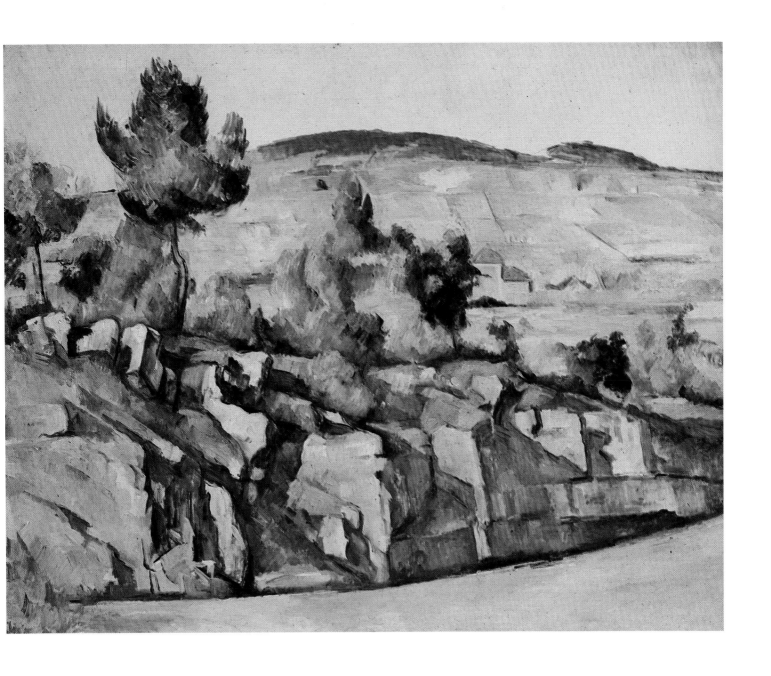

24 The Blue Vase

c.1885-7. Oil on canvas, 61 x 50 cm. Musée d'Orsay, Paris

The distortion we have seen in the landscapes and in the earlier still life (Plate 9), is applied to Cézanne's later arrangements of objects, fruit and flowers. It is not that he could not draw straight lines or elliptical curves - the far edge of the table here, for example, could have been drawn with a ruler. The off-centre placing of the vase on its stand and the virtual dislocation of the plate behind it must therefore have been deliberate. The blue vase, when we look closely, actually has numerous outlines, drawn in blue, white and red fine strokes of paint. This is not a record of Cézanne's repeated attempts to get the shape right. Rather, and this is what so excited the Cubists, Cézanne has shifted his viewpoint and allows us to see further round the vase, giving it real volume. Exactly the same happens with the thigh of the gardener in Plate 48.

Apart from constructional considerations, the painting is a delightful harmony of blues and ochres, from the delicate background hues to the more intense colours of the flowers and fruit.

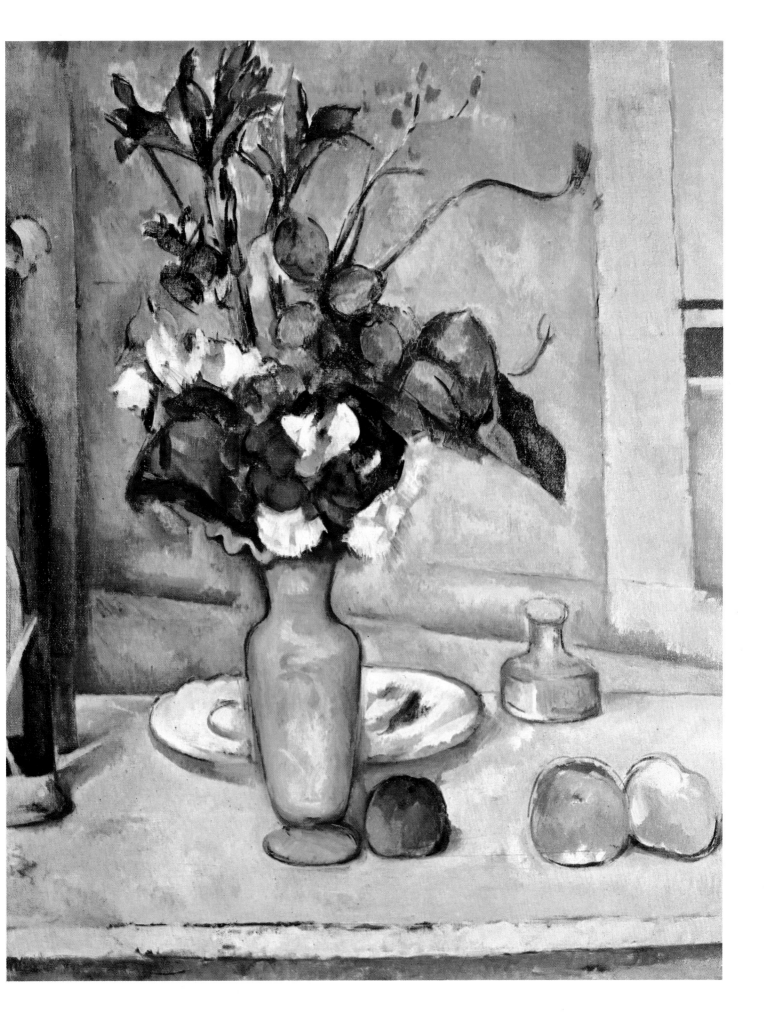

Still Life with Ginger Pot

c.1888-90. Oil on canvas, 65 x 81 cm. Musée d'Orsay, Paris

Here, too, we find shifting viewpoints, tilting of axes and dislocation of objects. The near side of the basket of fruit is seen full frontal, yet the handle has been turned, as if seen from the right, and we are able to look deeper than expected into the basket. The ginger pot is viewed from the same high eye level, and sits squarely on the table, even though it is in danger of falling off, so far back is it placed. The sugar bowl and jug, on the other hand, are tilted to the left. It is known that Cézanne sometimes used coins to prop up objects so that they could be angled artificially, allowing him to see into bowls, cups and so on.

One of the most striking discrepancies in this still life is the splitting of the table underneath the cloth draped over it. The two halves of the near edge do not align at all. Cézanne frequently allowed this to happen in his later paintings (see, for example, Plate 37, in which the dado rail is dislocated). The Cubists seized on this, drawing diagonal lines through cups and then shifting the halves apart, like a modern split lens on a camera.

c.1888-90. Oil on canvas, 79.5 x 64 cm. Fondation E.G. Bührle Collection, Zurich

The sitter for this portrait is identified by Venturi as Michelangelo di Rosa, an Italian professional model whom Cézanne painted several times, here dressed in the local costume of a peasant from the Roman Campagna. By now, Cézanne had again begun to live for periods in Paris, where this painting was apparently done. Rewald describes the apartment at 15 quai d'Anjou, one of Cézanne's many temporary homes, thus: '[it had] a wainscot or moulding, accompanied by a narrow wine-red band...there was also, near the fireplace, a small curtained door or opening'. Points of reference like this are invaluable when trying to date Cézanne's works (see also Plate 37).

The young lad sits with his head resting on one hand. Cézanne may have seen this pose in reproductions after examples such as Dürer's *Melancholia I*, Michelangelo's depiction of the damned in the Sistine ceiling, and Carpeaux's *Ugolino and his Sons*. Cézanne had previously used this pose in *The Temptation of St. Anthony* (Plate 5). As usual, Cézanne distorts, making the left arm overly long.

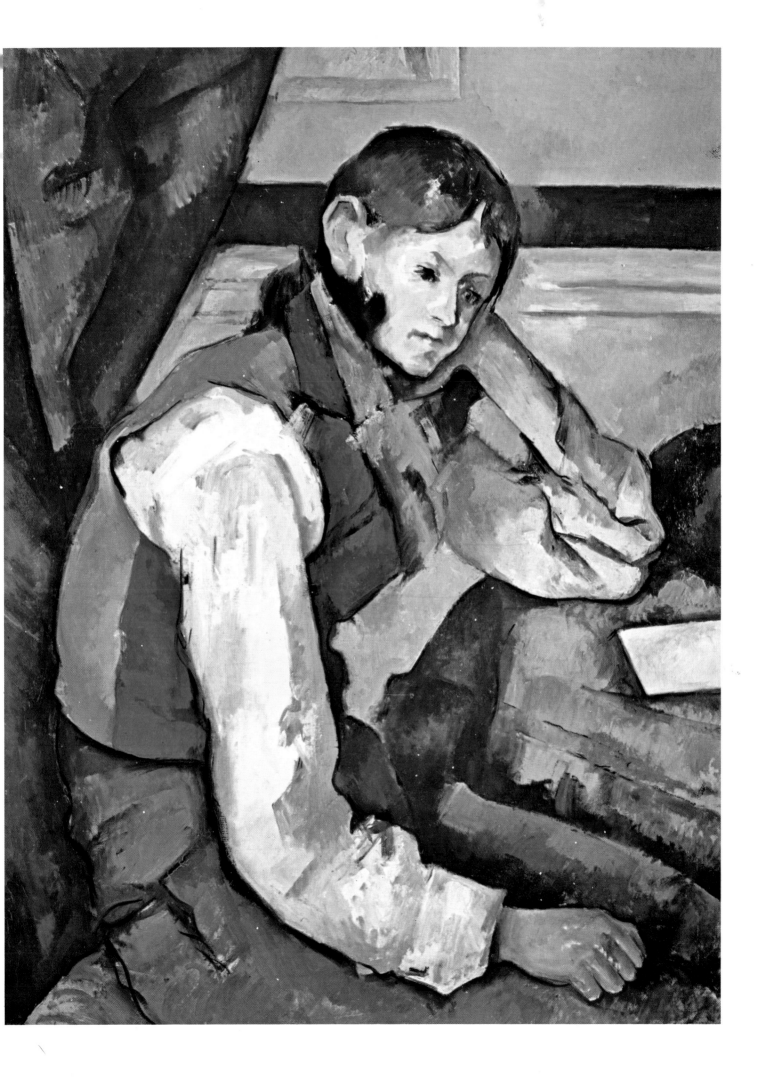

c.1888-90. Oil on canvas, 74 x 93 cm. Stavros S. Niarchos Collection, Paris

It is interesting to compare this picture with *The Bridge at Maincy, near Melun* (Plate 11), painted approximately ten years earlier. In both the principal motif is the bridge/aqueduct itself; in both Cézanne is interested in the reflections in the water and in the relationship of the manmade bridge with the surrounding natural environment. In this later picture in particular, each end of the aqueduct has been 'buried' in dense foliage, so that it appears to spring out of the trees with no means of support; in other words, it has become part of nature. The elongated reflections of the aqueduct (and of the other constructions) in the water similarly relate it to the landscape. As in Plate 11, no ripples have been allowed to disturb the harmony achieved by these different elements.

At the same time, the architectural forms provide the structure in nature that Cézanne always sought when choosing sites for his paintings. The regimented parallel lines gave him the freedom to paint masses of undefined foliage at the sides of the picture without losing any compositional clarity.

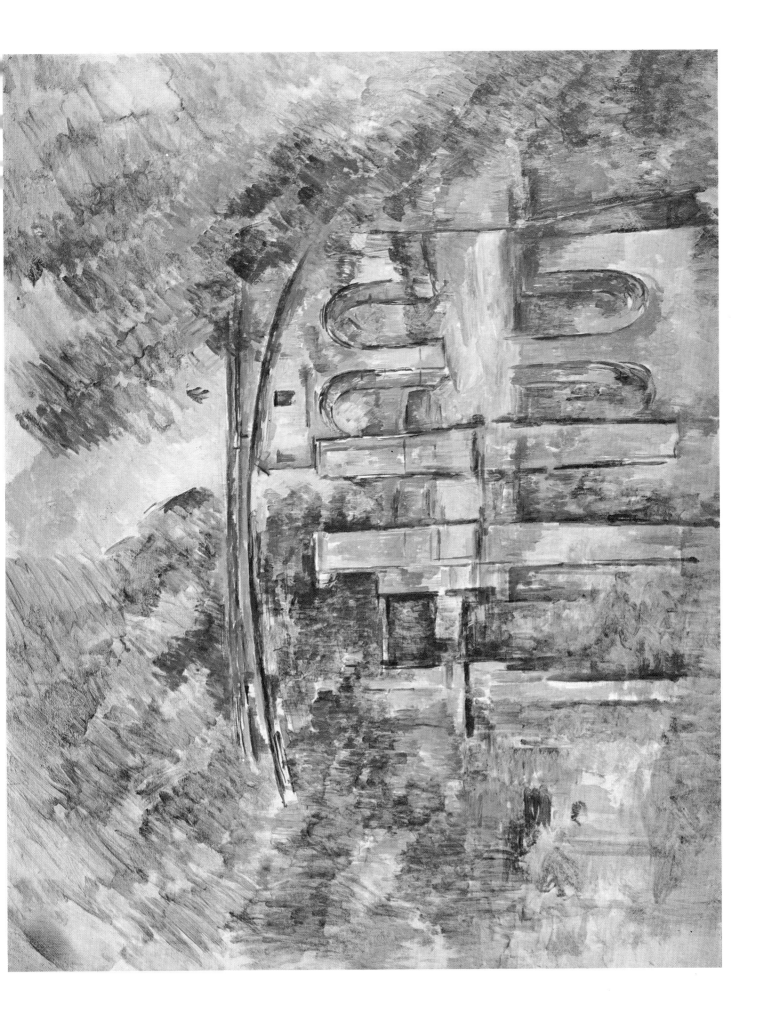

28 Bridge over the Marne

1888. Oil on canvas, 71 x 90 cm. Pushkin Museum of Fine Arts, Moscow

While living in the quai d'Anjou, Cézanne made several trips to the suburbs of Paris, painting about half a dozen views up and down the river Marne. The central motif in this painting is again a bridge, as in Plates 11 and 27. Here, however, the bridge is in the middle distance, and its colouring is rather dark and grey, tending to blend into the background. Indeed, the horizontal elements of it do not cast any reflection at all in the water, only the lighter-toned supporting pillar is mirrored; along with the other buildings, trees and clouds. The most intense colour accents are the red roof of the little house and the vivid green grass on the bank below it, in typical close juxtaposition. The light blocks of buildings and their reflections punctuate the bank leading into the distance, just as the houses in Plate 16 prevent the eye from skimming over the picture surface.

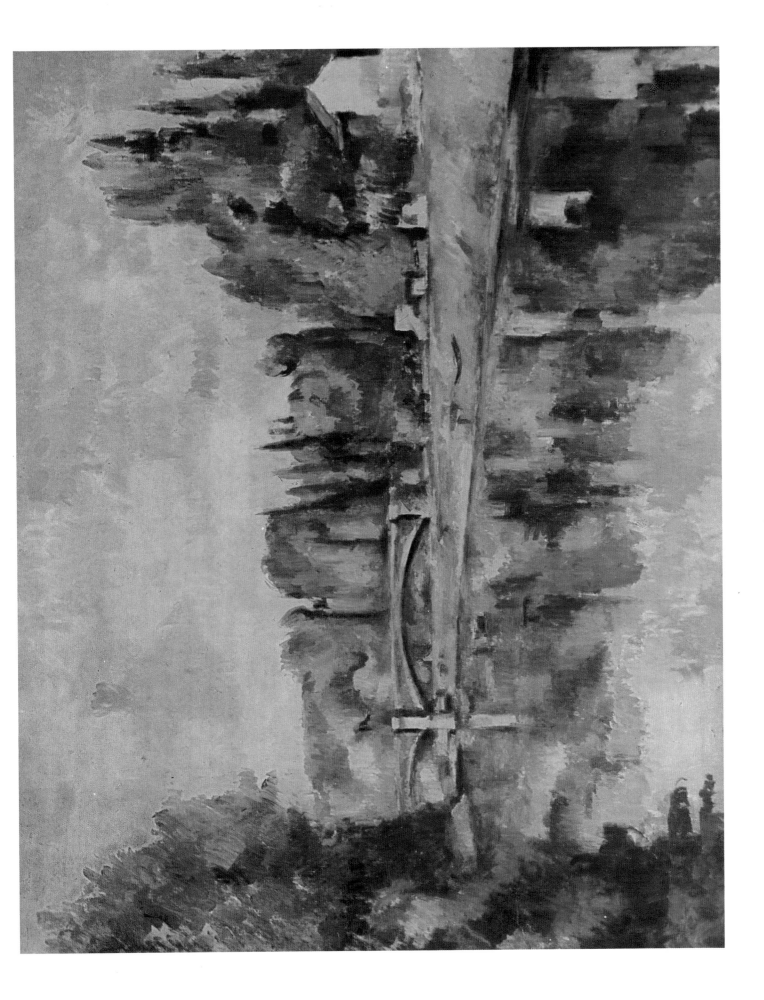

29 Woman with a Coffee Pot

c.1890-4. Oil on canvas, 130 x 97 cm. Musée d'Orsay, Paris

This monumental painting is probably of one of the servants at the Jas de Bouffan. The scale of the portrait, together with the quality of repose, give it an air of timelessness and universality, one for which Cézanne seems to have strived in his paintings of the people of Aix in the 1890s and early years of the twentieth century (see Plates 34, 35 and 39).

The tall slim *cafetière* and upright spoon in the coffee cup reflect the erectness of the woman. Vertical lines repeat themselves across the canvas in the edge of the decorative screen, in the panelling behind, and in the pleats of the woman's dress, rising from the base of the picture to her neck and continued in the shadows of her face; all, however, incline marginally to the left.

Breaking the rigidity of these parallels are the curved lines of her arms and pleats of her dress running from collar to waist. The bow at her waist appears to hold together not only her dress, but indeed the entire painting.

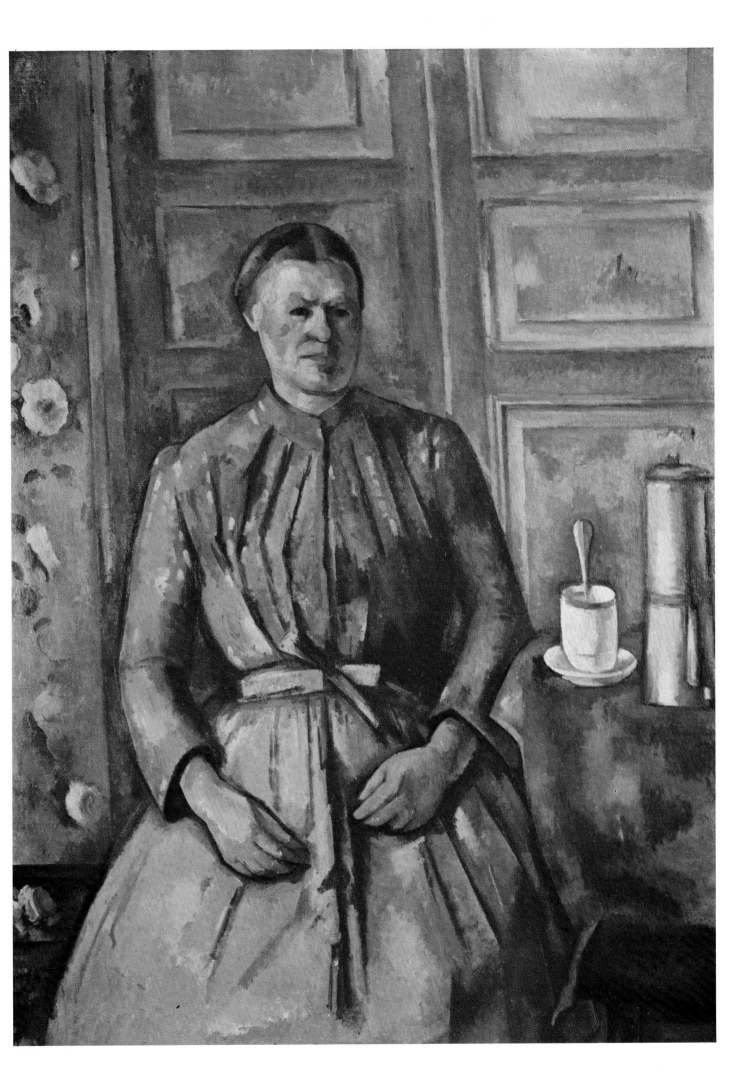

30 Self-Portrait with Palette

c.1890. Oil on canvas, 92 x 73 cm. Fondation E.G. Bührle Collection, Zurich

This is the largest of the many self-portraits, and the only one showing more than Cézanne's head and upper torso. It also portrays him as the artist; in the others we are given no clues as to his profession. Yet the portrait is more concealing than revealing - the painter is literally obscured by his art. The canvas he is working on, the very one that we are now looking at, hides his painting arm. The palette, tilted up so that it is parallel to and reinforces the picture plane, is directly aligned to his left arm (since this is a mirror reflection), again blocking off part of his body. Only his thumb emerges to point, with the brushes, at his canvas.

This portrait illustrates a letter Cézanne wrote to the poet Joachim Gasquet some years later: 'All my life I've worked in order to be able to earn my living, but I thought I could paint good things without drawing attention to one's private life. Of course an artist attempts to elevate himself intellectually as much as he can, but the man must stay in the background. The pleasure must stay in the work'.

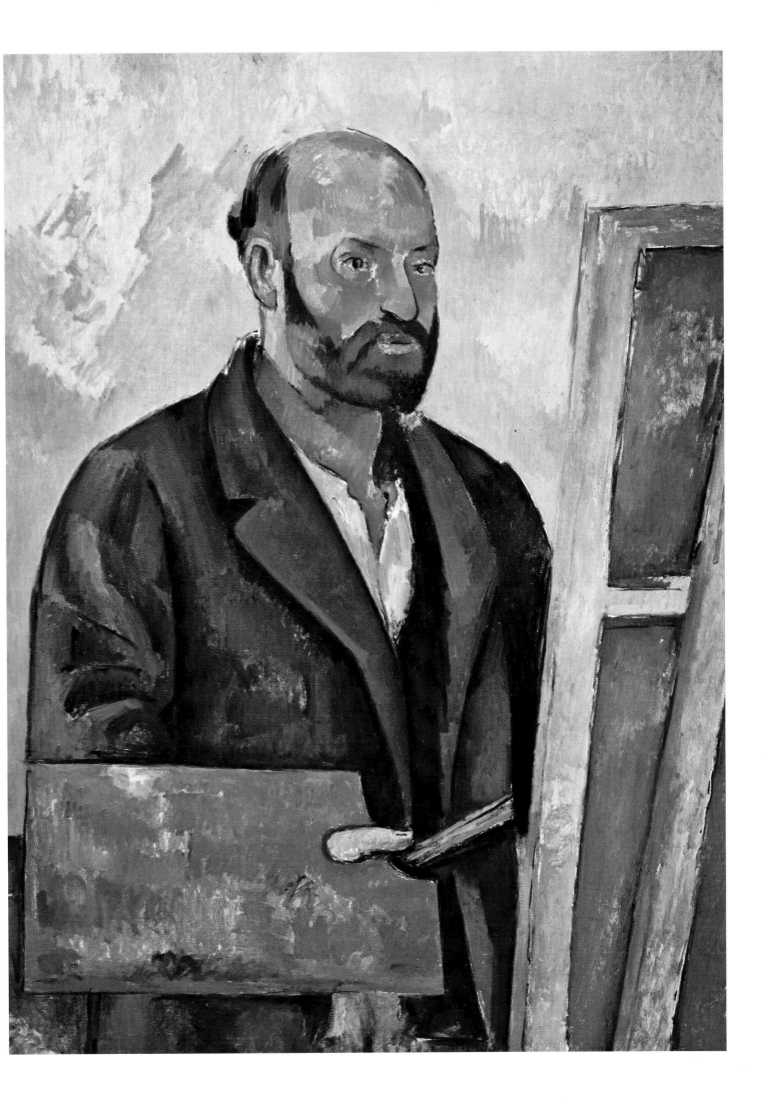

Dish of Peaches

c.1890-4. Oil on canvas, 32 x 41 cm. Oskar Reinhardt Collection, Winterthur

92

Cézanne never stopped studying from the Old Masters, even at this advanced stage in his career. This still life is copied from a painting in the Musée Granet in Aix-en-Provence, attributed to Laurent Fauchier (1643-72) who lived in Aix all his life. It is typical of Cézanne to have chosen a local artist to copy.

The subject is a simple one, a bowl of peaches on a table, but there are the usual spatial ambiguities. The plate is tipped up the better to display the fruit; so too in Fig. 27. The drapery on the right extends from the top to the bottom of the picture, making it difficult to tell whether it is lying horizontally, held on the table by the plate, or in some way trailing from a support at the back of the arrangement. The dark blue triangular shape must relate the table to the wall behind, but is curiously flat. This may be partly to do with Cézanne's apparent changes of mind in deciding the outlines of the various forms; patches of brown show through the relatively thinly painted blue, indicating a previous position of the table.

Fig. 27
Basket of Apples
c.1895. Oil on canvas, 65 x 80 cm. Helen Birch Bartlett Memorial Collection, Art Institute of Chicago

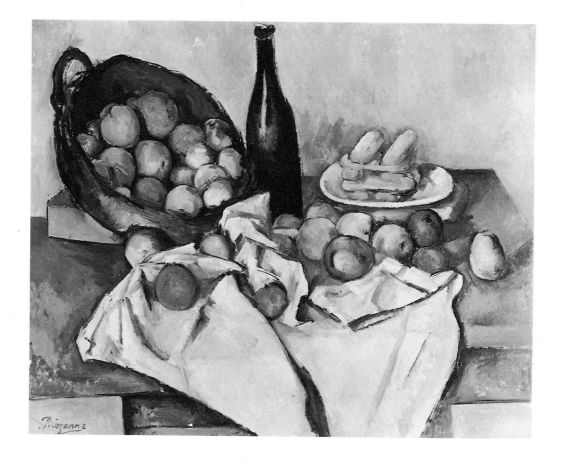

c.1892-4. Oil on canvas, 53 x 71 cm. Tate Gallery, London

This painting and Fig. 28 remain unfinished, thus showing Cézanne's method of working. As in *The Village of Gardanne* (Plate 18), he has first drawn the outlines in graphite pencil and then brushed in the heaviest ones with blue-grey paint. He has established the table top on which the apples, knife, plates and pot are placed, and blocked in the wall behind the spherical pot, which echoes the shape of the fruit, to give the objects a spatial context.

The emphasis he places on outlines is interesting. He has worked hard on the delineations between objects, so that the rounded body of the pot stands out from the background wall, apples are positioned in front of one another, and folds of drapery clearly marked.

He also appears to have sketched in some axes, tilting in different directions as we have already seen in Plate 25. While the pot is virtually vertical, lines on the wall, which presumably would mark gradations of colour, are not parallel. The overall effect, particularly in this unfinished state, is a flattened one.

Fig. 28
Still Life
c.1906. Watercolour, 47 x 62 cm. Estate of Henry Pearlman, New York

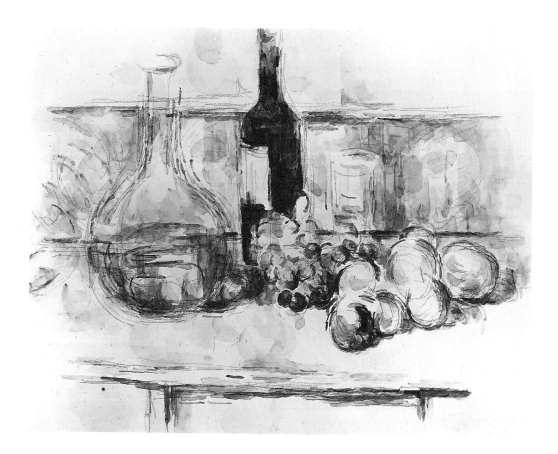

33　Sous-bois

c.1892-4. Watercolour, 31 x 47 cm. Sold Christie's London, 30 November 1987

Fig. 29
Les Arbres
c.1890-4. Watercolour. Princesse de Bassiano, Paris

This is one of a number of watercolours that Cézanne made in the Forest of Fontainebleau (see Fig. 29) and in the park of the Château Noir in Provence, which he tried unsuccessfully to buy. Again, the example of Granet – who donated over 1,500 watercolours, drawings and washes to the local museum, many of them done in the Fontainebleau and Aix areas – may have been the initial inspiration for Cézanne's choice of subject and medium.

Unlike Granet and his predecessors, the painters of the Barbizon school, Cézanne places himself right in the forest itself, so that there is no real fore-, middle- and background in the traditional sense. Instead we are surrounded by the trees, with no skyline visible. The placing of a path parallel to the picture plane further adds to the impression of enveloping forest; a winding path leading from immediate foreground through the trees in the manner of the Dutch seventeenth-century painters would indicate the conquering of nature by man. This immersion in nature would seem to reflect Cézanne's characteristically nostalgic attitude towards the countryside of Provence.

c.1892-5. Oil on canvas, 60 x 73 cm. Courtauld Institute Galleries, London

This nostalgia is felt in another painting of the local inhabitants of Aix, two men seated at a table, seen in profile, playing cards. It could be said that the careful consideration the players give to their hands of cards is a way of making time stand still. This work although not on the monumental scale of *The Woman with a Coffee Pot* (Plate 29), lends the participants the same quality of dignity and repose.

The painting is also an exercise in the balance of warm and cool colours. Around the principal warm focus, the red-orange table top, are touches of ochre in the figures and surroundings. Apart from these, the canvas is dominated by cool greenish-blues. Small patches of unpainted cream canvas show through to serve as highlights on the hands and sleeves of the players.

Fig. 30
Card Players
c.1890-2. Oil on canvas, 133 x 179 cm. Barnes Foundation, Merion

Although the partition behind the figures continues on either side of the heads in a straight line, the table is extremely lopsided. Nor are the figures proportional, the knees of the man on the left extending too far to the right. Fig. 30 shows an earlier, much larger version of the subject.

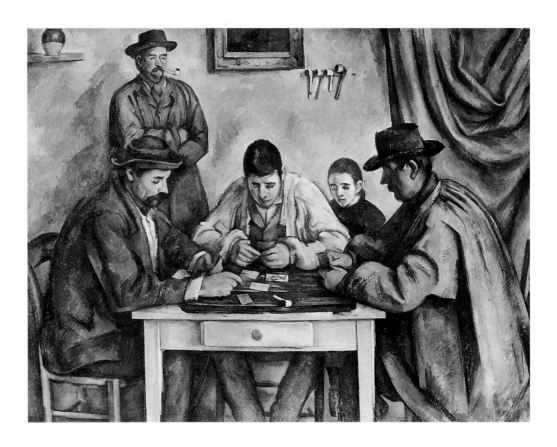

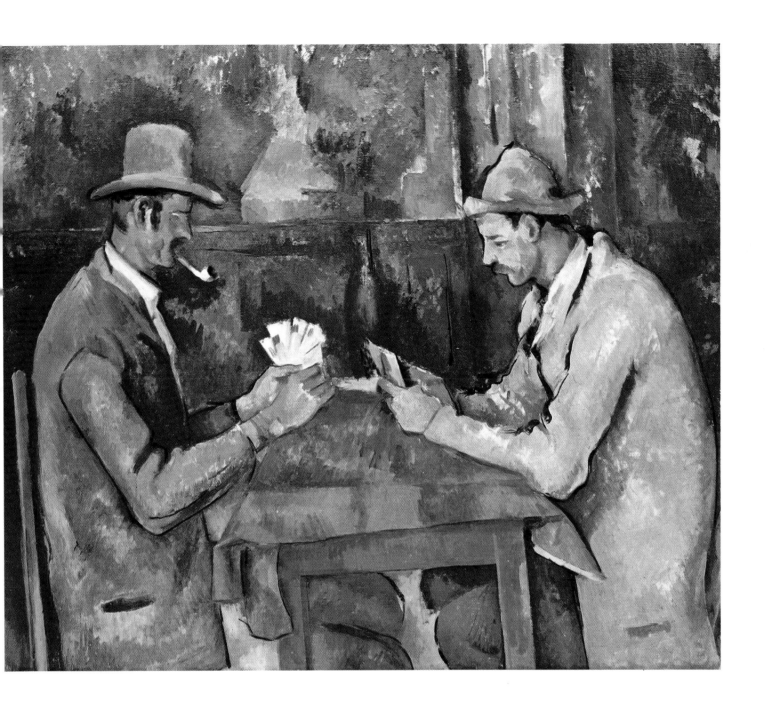

35 Man with a Pipe

c.1892-5. Oil on canvas, 73 x 60 cm. Courtauld Institute Galleries, London

The model for this portrait is the lefthand figure from the previous painting, a gardener at the Jas de Bouffan known as *le père Alexander*. He seems to wear the same clothes and distinctive hat, and his pipe is set at the same angle.

The background is left almost plain, with horizontal lines at hat and neck level barely suggesting the passage from ceiling to wall to ground behind him. Instead Cézanne focuses on the figure himself, who is set centrally in the picture and who shares the muddy greenish-browns of his surroundings, appropriately enough for a gardener perhaps. The lightest area of the portrait is that formed by the man's face, collar and hat, the clothes near his face taking on hues from his skin colour, warm pinks and ochres. In the modelling of the face Cézanne's palette ranges from black through deep red to cream, hatched in parallel diagonals, in the kind of constructive stroke he used around 1880 in paintings such as *The Bridge at Maincy, near Melun* (Plate 11).

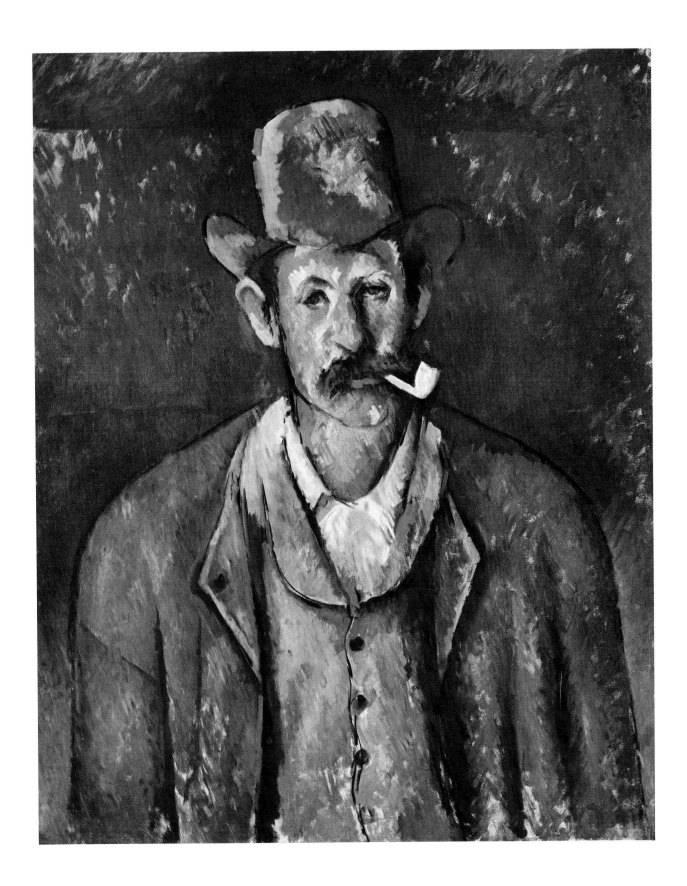

Man with a Pipe

c. 1892-5. Watercolour, 48.6 x 32.7 cm. Private Collection

This is one of a number of preparatory drawings Cézanne made for his paintings of card players, again of *le père Alexander*. That the subject interested him greatly there is no doubt: 'Today everything has changed in reality, but not for me, I live in the town of my childhood, and it is with the eyes of the people of my own age that I again see the past. I love above all else the appearance of the people who have grown old without breaking with old customs'.

In this study Cézanne is concerned with understanding the relationship of the different elements to each other; of limbs to body, neck to shoulders and hat to head. As with the unfinished still life in Plate 32, he establishes the spatial relationship of subject to background, shading this quite heavily.

Cézanne appears happy to leave the rest of the page empty, having studied the parts that interest him most. When questioned in 1905 about his distortions he replied: 'I am a primitive, I've got a lazy eye. I presented myself to the Ecole [des Beaux-Arts], but I could never get the proportions right: a head interests me, and I make it too big'.

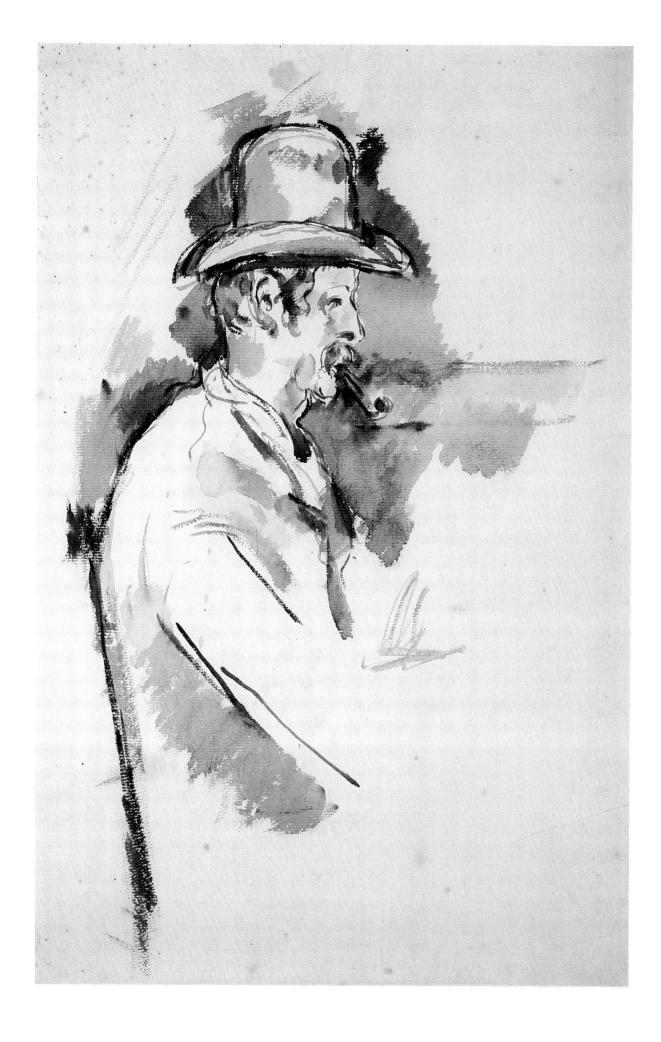

c.1893-5. Oil on canvas, 80.9 x 64.9 cm. Art Institute of Chicago

Cézanne continued to paint his wife throughout his career (see Plate 14); this is one of three versions of the same pose and setting. The composition is deceptively simple - Madame Cézanne sits in a damask-covered armchair in front of a wall divided by a dado rail. Colours and shapes are repeated, uniting the picture surface. The primary coloured blue wall, yellow chair and red dress are brought together in the shading around the sitter's mouth, so that she links and is linked to the separate pictorial components. The smooth oval of her face mirrors the angle and position of her body, arms and shoulders. Some of the tension in the marriage can be seen in the fidgeting interlocking of Madame Cézanne's fingers, and in the unsettling disjunction between the two sections of the heavy black dado rail, which would not meet were the horizontal lines extended.

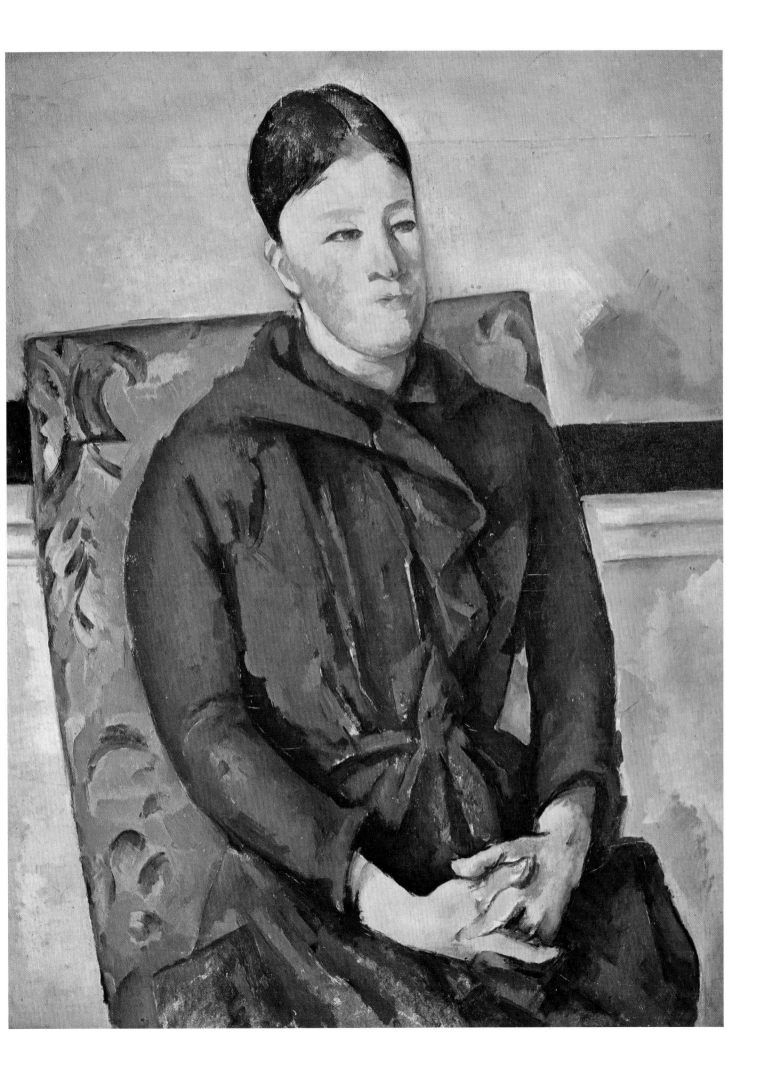

38 La Colline des Pauvres

c.1890-5. Oil on canvas, 81.3 x 65.2 cm. Metropolitan Museum of Art, New York

In 1891 Cézanne became a devout Catholic, which may well have influenced the subject matter of this picture and the next. The cluster of small buildings in this landscape is a Jesuit estate. Cézanne had treated religious themes during his early romantic period, as in *The Temptation of St. Anthony* (Plate 4), or in an erotic composition of c.1861, *Lot and his Daughters*, which owed more to his adolescent fantasies than to the Bible. A number of his views of villages in the 1890s feature a prominent church or church tower.

In this later work there is no obvious moralizing point, other than the harmony which exists between manmade buildings and nature. Again, the uniform treatment of each in terms of brushstroke and colour ensures that the Jesuit buildings are at one with their surroundings.

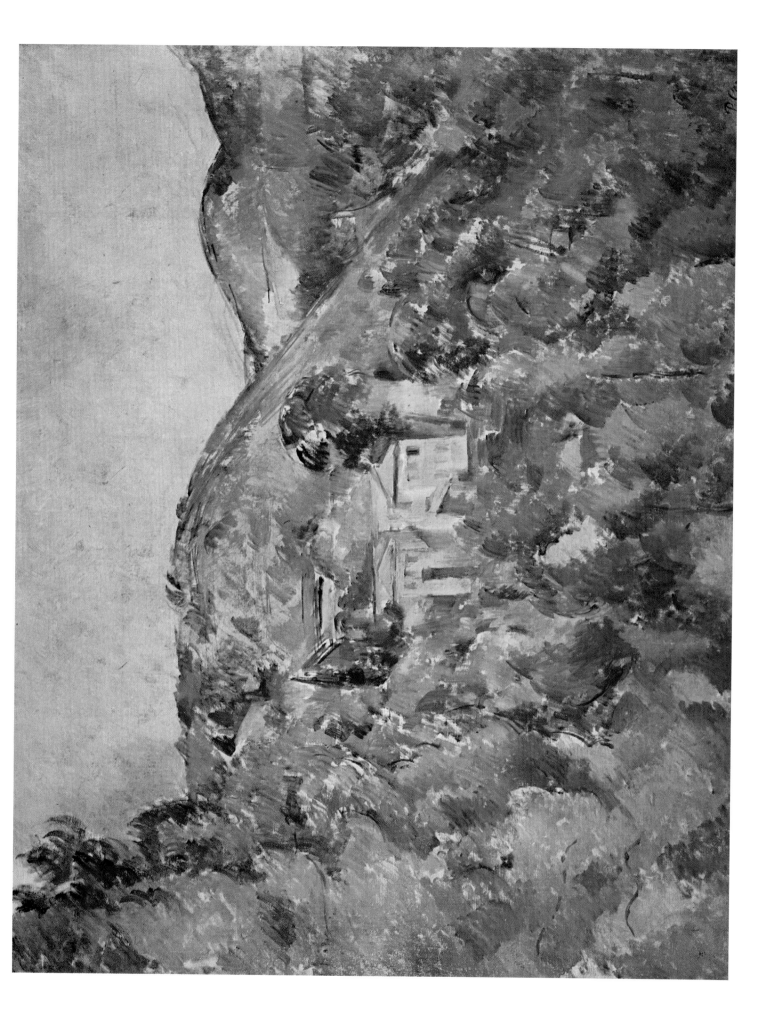

Old Woman with a Rosary

c.1896. Oil on canvas, 81 x 61 cm. National Gallery, London

This portrait was made in homage to *Woman Knitting*, by Duparc, a native of Provence. The model for the picture was an old woman whom Cézanne allowed to live at the Jas de Bouffan. The story goes that she escaped from a convent at the age of 70, having lost her faith and, finding her wandering in the countryside, Cézanne took pity on her. She may be the 'old invalid', referred to in the introduction, who posed for the late bathers paintings.

The sombre subject and sober colouring again show the revival of Cézanne's earlier interest in religious themes. The deep blues and blacks are relieved only by the ochre coloured hands and face and the white cotton bonnet. It is possible to see the changes in the outline of the woman's left shoulder, gradually raised to its present high position, making her head increasingly bowed and her mood more contemplative.

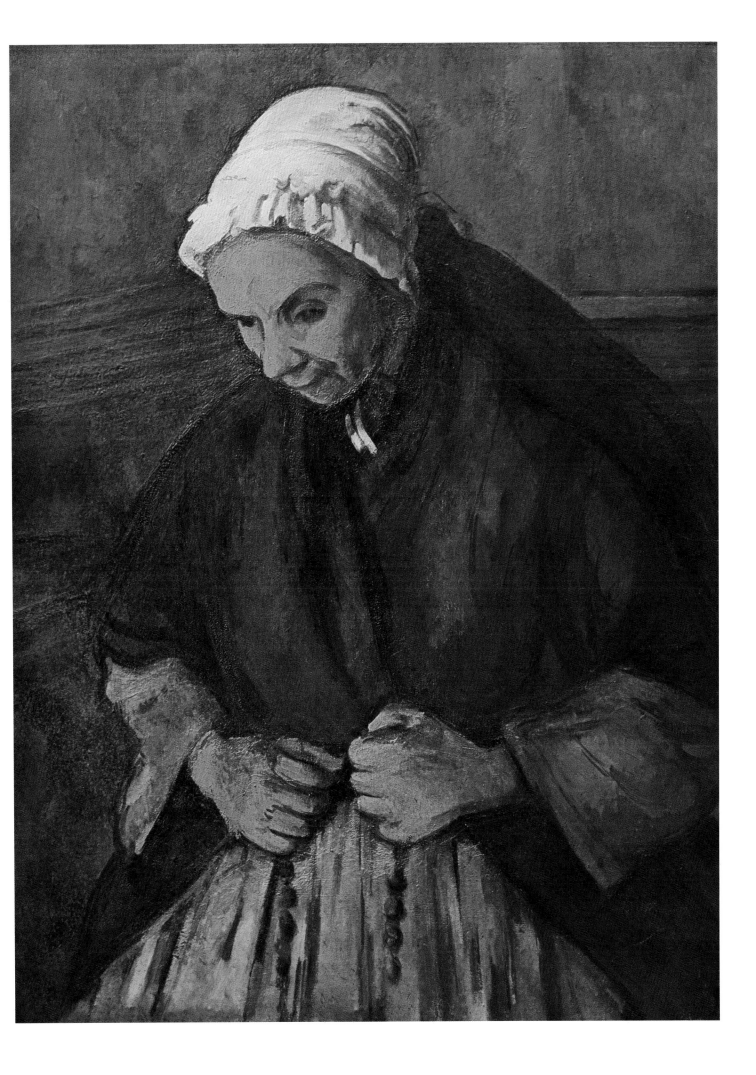

1896. Oil on canvas, 65 x 81 cm. Courtauld Institute Galleries, London

In the summer of 1896 Cézanne holidayed in Talloires, where he painted this view across the Lac d'Annecy looking towards the Château de Duingt on the opposite shore.

Although the Château is a mile away, Cézanne makes it seem nearer by narrowing the visual field and by using the large tree to link fore- and background. The foliage of its framing branches merges almost indistinguishably with the distant hillside by sharing the same type of brushstroke and depth of colour. Some of the slanting lines in the upper half of the picture might represent branches or mountain ridges, while touches of the same shade of blue are found in lake, *repoussoir* bank, tree trunk, foliage, hills and buildings. The reflections in the water also connect view with viewpoint, condensing the scene and tilting it towards us slightly. Cézanne is, as ever, interested in the contrasts of warm and cool colours, outlining the orange roof of the building on the right with complementary Prussian blue, and rounding tree trunk and tower by using warm-cool contrasts rather than tonal ones.

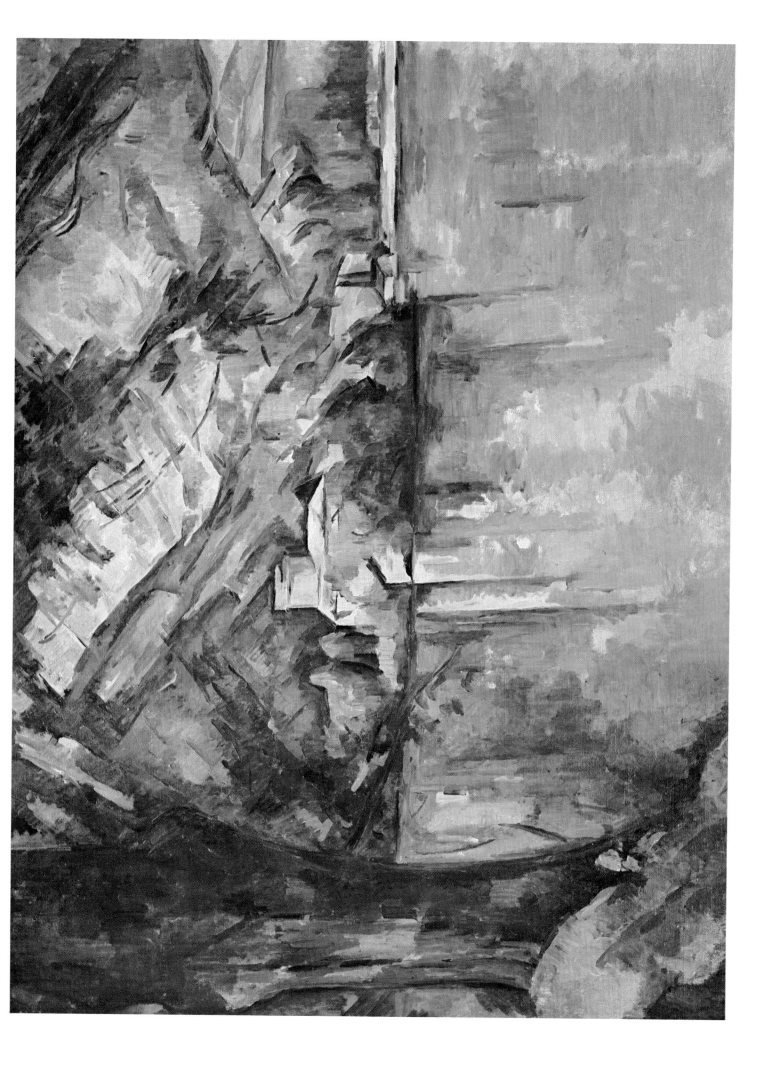

1899. Oil on canvas, 100 x 81 cm. Petit Palais, Paris

This portrait of the dealer who gave Cézanne his first one-man exhibition in 1895 shares the symmetry and quality of repose of *Woman with a Coffee Pot* (Plate 29). There is a similar interest in the folds of the clothes, the crisp lines of the jacket and waistcoat collars forming essential structural axes. The criss-crossing of diagonals is repeated in the shape of Vollard's head, with its neat beard, and in the angular bow tie. The pose itself is used again in the 1906 painting of *The Gardener* (Plate 48), in which Cézanne explores the outline of the man's thigh, overpainting the contour until the viewpoint seems to move around the seated figure. Here too, a series of strokes defines the underneath of Vollard's right thigh.

Vollard records Cézanne's outburst when he fell asleep one day while posing for this unfinished work: 'You wretch! You've destroyed my pose. Do I have to tell you again you must sit like an apple? Does an apple move?'

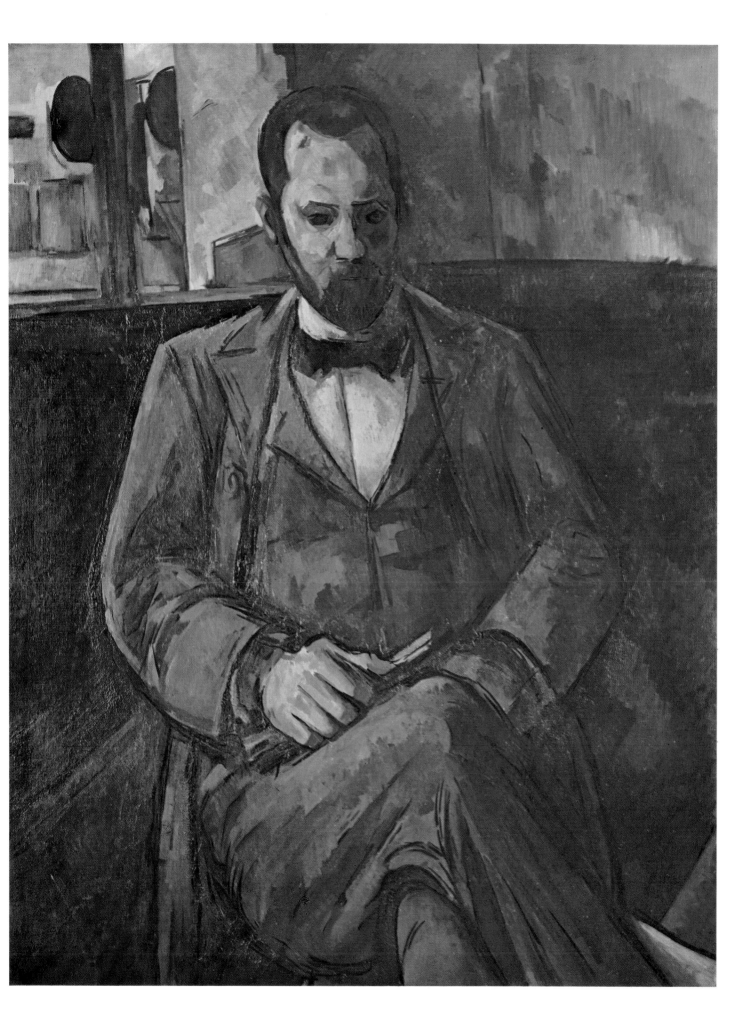

The Bathers

c.1899-1904. Oil on canvas, 51.3 x 61.7 cm. Art Institute of Chicago

The dozens of studies and paintings that Cézanne made of bathers throughout his life come to a climax in this and the following two works, painted between about 1900 and 1906. Familiar shapes and poses reappear again and again. There is the standing figure based on Michelangelo's *Dying Slave*, already employed in Plate 5 and Fig. 15. It is thought that the central figure in Picasso's *Les Demoiselles d'Avignon* of 1907 may be derived from Cézanne's interpretations.

Compared to the other two large bathers scenes, the Chicago example is sketchier and less finished. The curling outlines of the bodies are similar to the watercolour (Fig. 31). Grass, leaves, trees, water and sky are roughly hatched in diagonal strokes of blue and green paint; highlights of vermilion provide sharp bright accents. Overall, the effect is rather like a pattern. Cézanne seems to be interested not in the individual figures - two on the right are headless - but in the whole canvas surface, in an attempt to naturalize the presence of naked figures in a landscape.

Fig. 31

Bathers

c.1900-06. Watercolour, 18 x 25 cm. Location unknown

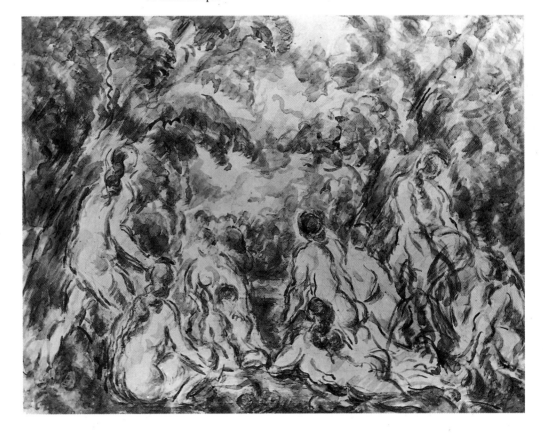

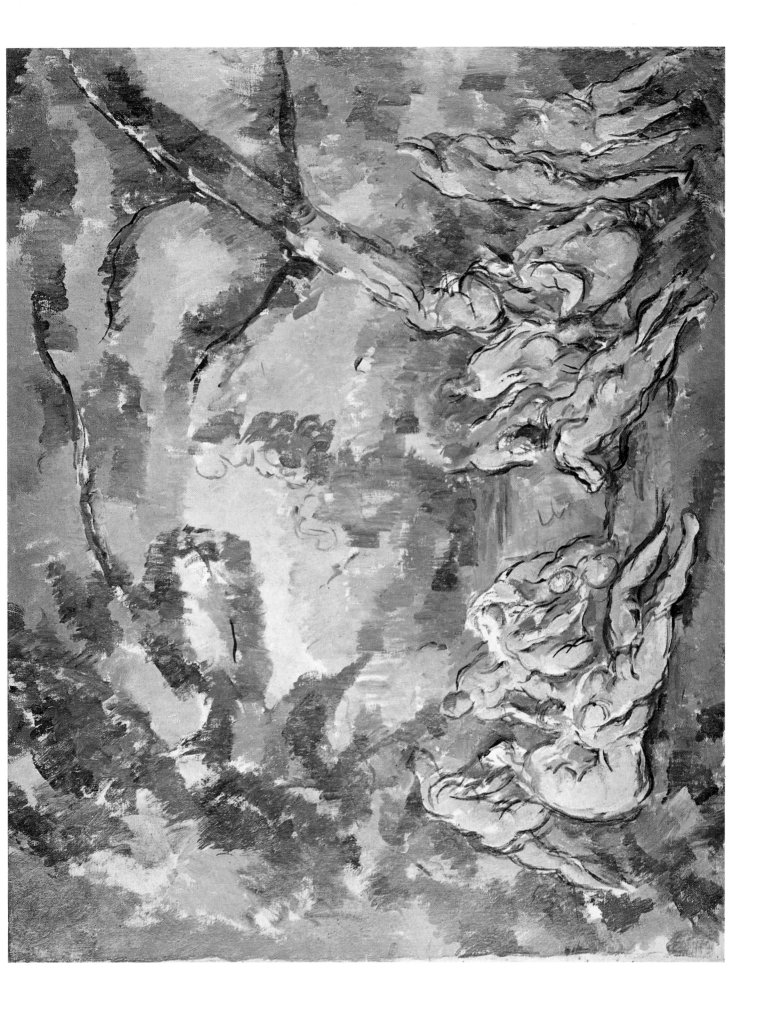

c.1900-5. Oil on canvas, 130 x 195 cm. National Gallery, London

This comparison with Fig. 32 neatly illustrates how far Cézanne has moved in the distortion, or disguising, of the individual form. In the National Gallery painting, the hermaphroditic quality of the monumental figures is clearly evident. In the early *Temptation of St. Anthony* (Plate 5), he replaced the head of the female figure on the right with the head of Zola; in the same way he transformed the *Dying Slave* into a female seductress.

Here, however, the forms are subordinated to the demands of the composition. The standing figure on the left parallels, and is aligned with, the inward leaning tree behind, limbs of figure and tree trunk only differentiated by colour.

The little still life arrangement in the centre has been compared by some critics to that in Manet's *Déjeuner sur l'Herbe*, 1865. However, the entire picture is more loosely painted and lacks the obvious social comment implied in Manet's combination of naked women with clothed men.

Fig. 32
Male Bathers
1888-90. Oil on canvas, 54 x 65 cm. Private Collection, Paris

c.1906. Oil on canvas, 208 x 249 cm. Museum of Art, Philadelphia

This is the largest of the three paintings, and its composition is also the most formal. It is known that Cézanne drew a diagram of the composition of Veronese's *Supper at Emmaus* (Fig. 33), and there are strong similarities between the two. In both, the figures are grouped into two three-dimensional pyramids on either side of the centre. In Veronese's picture this is occupied by a table, so that there are two planes, the near side (parallel to the picture plane) and the table top (perpendicular to the picture plane). Cézanne has played on this, placing a band of dark blue river (which recedes) between two bands of ochre coloured earth (which advance). All three bands are perpendicular to the picture plane, yet appear to have different properties.

In another variation on the sixteenth-century work, Cézanne has replaced the figure of Christ behind the table with a distant church spire. The triangular pediment above Christ's head, a reference to the Trinity, is expanded out into a larger triangle formed by the framing trees and horizontal bands.

Fig. 33
Paolo Veronese
The Supper at Emmaus
Oil on canvas. 237 x 409 cm. Musée du Louvre, Paris

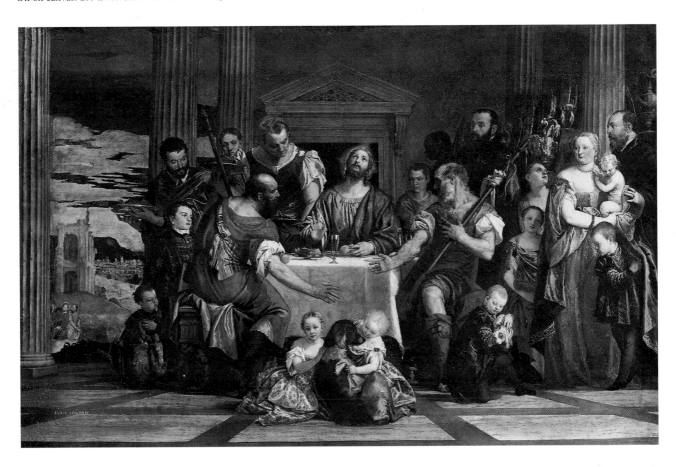

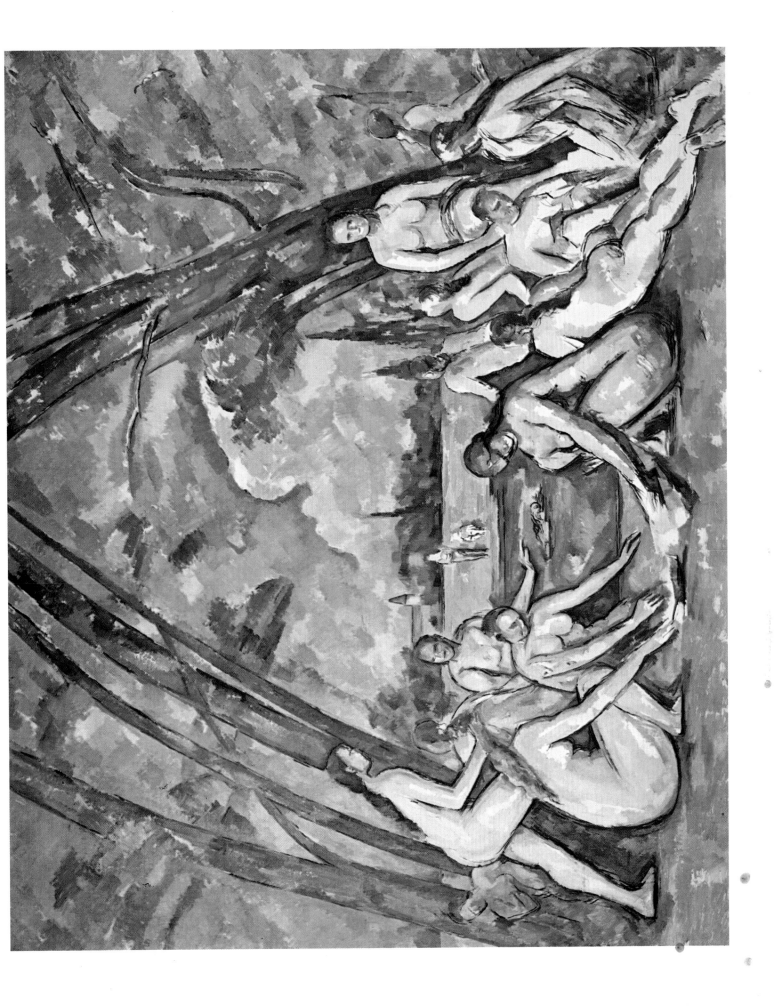

45 La Montagne Sainte-Victoire

c.1900-6. Watercolour, 36 x 55 cm. Tate Gallery, London

Cézanne painted 28 watercolours of the Mont Sainte-Victoire between about 1900 and 1906, most of them looking across the valley from Les Lauves, the studio he built in 1902 just north of Aix. From this spot he had an uninterrupted view of the mountain rising out of the landscape. Although he had experimented in watercolours throughout his career, the majority date from the last decade of his life.

Emile Bernard recalled watching Cézanne paint in this medium in 1904: 'His method was remarkable, absolutely different from the usual process, and extremely complicated. He began on the shadow with a single patch, which he overlapped with a second, then a third, until all those tints, hingeing one to another like screens, not only coloured the object but modelled its form'.

There are the barest traces of pencil over which Cézanne has laid these overlapping patches of colour, allowing each layer to dry before applying another. Most remarkable of all is the way in which the unpainted areas of paper have become a positive colour; the very whiteness representing the brilliant sunlight.

The Château Noir

c.1904. Oil on canvas, 73 x 92 cm. Oskar Reinhardt Collection, Winterthur

Fig. 34
Pistachio Tree in the Courtyard of the
Château Noir

c.1900. Watercolour and pencil on paper, 54 x 43 cm.
Art Institute of Chicago

The Château Noir was built in the mid-nineteenth century, but abandoned incomplete. Known locally as the Château du Diable - presumably because its former owner was an alchemist, whose experiments convinced his neighbours that it was inhabited by the devil - it held obvious appeal as a subject for Cézanne, who made an unsuccessful attempt to buy it. Nevertheless he obtained permission to paint in the surrounding estate, where the prospect of nature claiming back land temporarily lost to development provided material for about ten paintings, as well as several watercolours, such as Fig. 34.

The format can be compared to that of *The Bridge at Maincy, near Melun* (Plate 11). Tall thin trees frame the central motif, in this case the Château; and again there are the diagonally sloping branches which lend interest and density to the canvas surface and composition. The greens and browns of the enveloping forest are contrasted with the warm colour of the Château's walls and the bright red door. A glimpse of blue sky through an empty window is a touch of pure complementary colour.

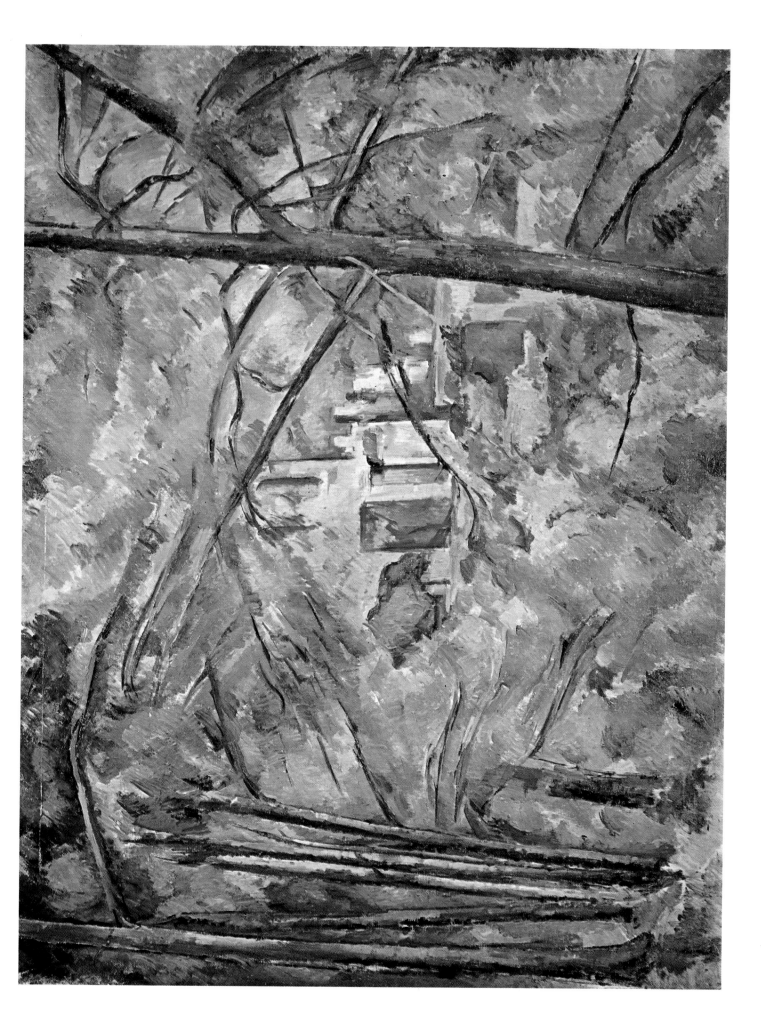

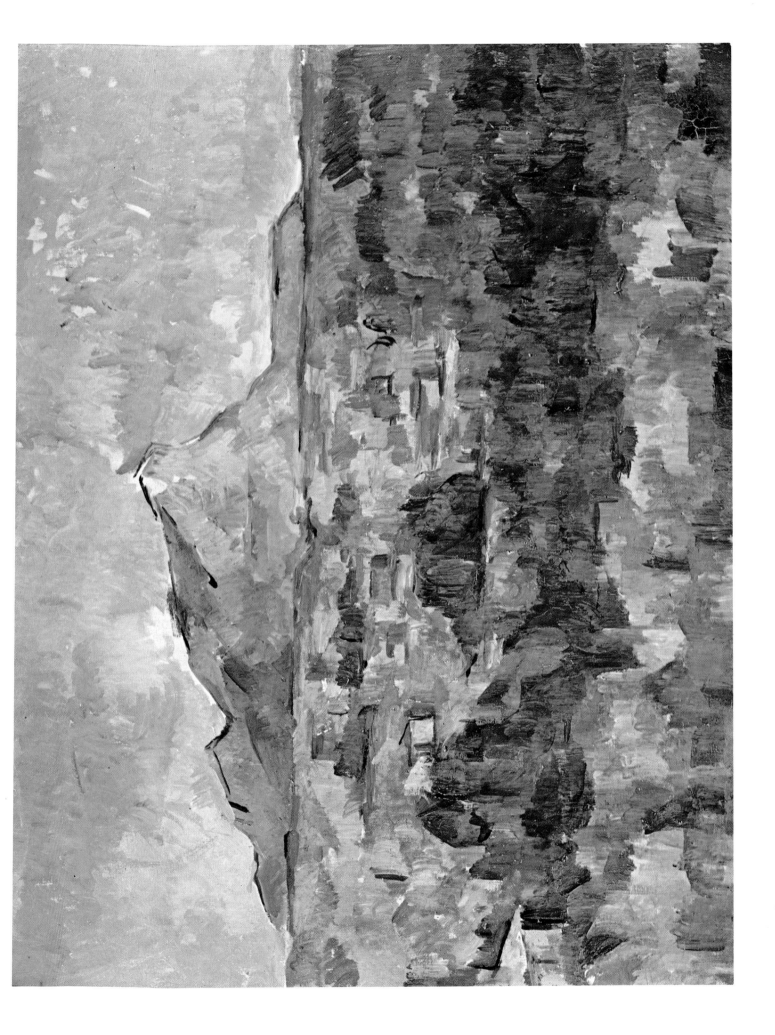

The Gardener

c.1906. Oil on canvas, 65.4 x 54.9 cm. Tate Gallery, London

Fig. 35
Portrait of Vallier
c.1906. Oil on canvas, 65 x 54 cm. Private Collection.

This portrait is thought to be the one that Cézanne was working on when he died in October 1906. In the last year of his life Cézanne painted six portraits in all of Vallier (see Fig. 35), the gardener at Les Lauves. The two reproduced here, and another in a private collection, in the full-length pose, are all the same size; it is possible that he may have wished them to be hung together. The other three images are slightly smaller watercolour and pencil sketches, again two full-length and one half-length profile. In all of them, Vallier crosses his right leg over the left one, in the same pose as Plate 41.

In part, these represent a continuing interest in the peasants of Provence, in the portrayal of 'types' that also interested Van Gogh. But, for the Cubists not least, what particularly attracts the attention is the shifting viewpoint, seen in the repeated outlines of the man's thigh and shoulders, so that we appear to be able to see round the form. The shoulder is given volume and solidity by the modelling of it in three different shades of blue; but this is then denied by the awareness of the canvas as a two-dimensional surface.

PHAIDON COLOUR LIBRARY
Titles in the series

FRA ANGELICO
Christopher Lloyd

BONNARD
Julian Bell

BRUEGEL
Keith Roberts

CANALETTO
Christopher Baker

CARAVAGGIO
Timothy
Wilson-Smith

CEZANNE
Catherine Dean

CHAGALL
Gill Polonsky

CHARDIN
Gabriel Naughton

CONSTABLE
John Sunderland

CUBISM
Philip Cooper

DALÍ
Christopher Masters

DEGAS
Keith Roberts

DÜRER
Martin Bailey

DUTCH PAINTING
Christopher Brown

ERNST
Ian Turpin

GAINSBOROUGH
Nicola Kalinsky

GAUGUIN
Alan Bowness

GOYA
Enriqueta Harris

HOLBEIN
Helen Langdon

IMPRESSIONISM
Mark Powell-Jones

**ITALIAN
RENAISSANCE
PAINTING**
Sara Elliott

**JAPANESE
COLOUR PRINTS**
J. Hillier

KLEE
Douglas Hall

KLIMT
Catherine Dean

MAGRITTE
Richard Calvocoressi

MANET
John Richardson

MATISSE
Nicholas Watkins

MODIGLIANI
Douglas Hall

MONET
John House

MUNCH
John Boulton Smith

PICASSO
Roland Penrose

PISSARRO
Christopher Lloyd

POP ART
Jamie James

**THE PRE-
RAPHAELITES**
Andrea Rose

REMBRANDT
Michael Kitson

RENOIR
William Gaunt

ROSSETTI
David Rodgers

SCHIELE
Christopher Short

SISLEY
Richard Shone

**SURREALIST
PAINTING**
Simon Wilson

**TOULOUSE-
LAUTREC**
Edward Lucie-Smith

TURNER
William Gaunt

VAN GOGH
Wilhelm Uhde

VERMEER
Martin Bailey

WHISTLER
Frances Spalding